I Am Home

I Am Home

PORTRAITS OF IMMIGRANT TEENAGERS

Photographs by Ericka McConnell
Edited by Rachel Neumann

Foreword by Thi Bui

PARALLAX
PRESS

BERKELEY, CALIFORNIA

Parallax Press
P.O. Box 7355
Berkeley, California 94707
parallax.org

Parallax Press is the publishing division of
Plum Village Community of Engaged Buddhism, Inc.

Printed in Canada

Cover and text design by Debbie Berne

ISBN: 978-1-946764-11-9

Library of Congress Cataloging-in-Publication Data
is available upon request.

1 2 3 4 5 / 22 21 20 19 18

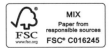

I am from there. I am from here.
I am not there and I am not here.
I have two names, which meet and part,
and I have two languages.
I forget which of them I dream in.

—Mahmoud Darwish

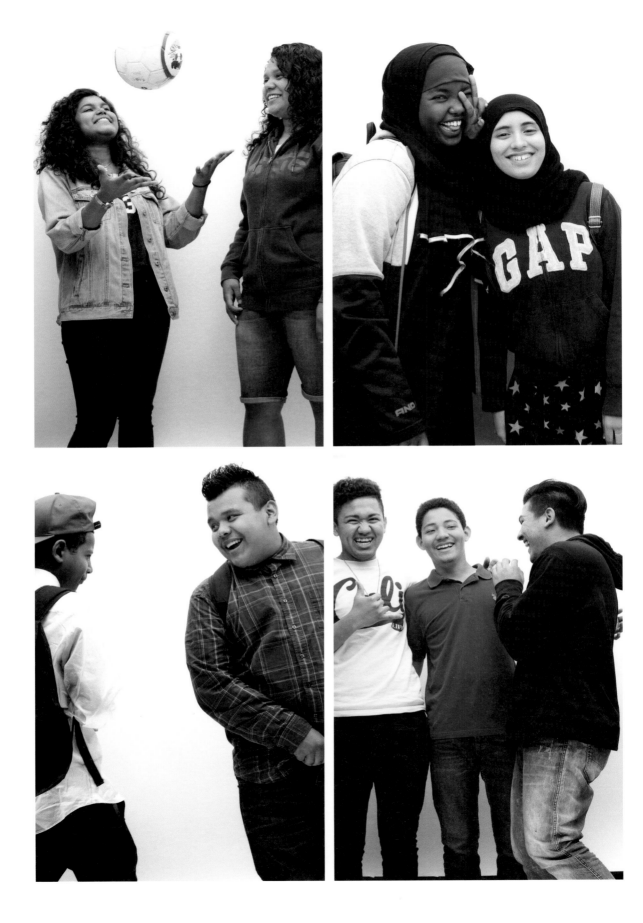

Contents

Foreword

When I was nineteen, I took my first art class with the teacher who taught me how to draw. For our final assignment, a self-portrait, I drew a larger than life version of me, posing behind a headless statue. I have lost track of the original drawing, so I drew a smaller version for you here.

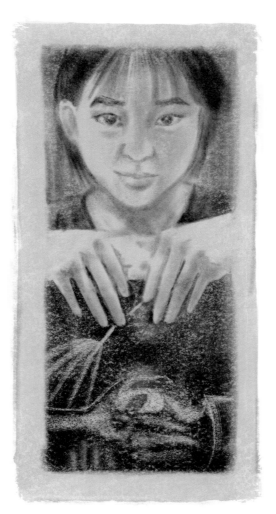

The reason for centering my hands was to say, *I am what I do, not what I appear to be.* That part I still believe. The rest was put together to the best of my ability with what was available to me at the time. The statue was supposed to be Buddha, to represent a part of my heritage, but I think it was actually a copy of a Sumerian statue that sat in one of the art studios at my university.

The real value of the drawing was the time I spent looking at myself and coming to terms with my face. I had never come across a large drawing or painting in a museum that looked like me. I hadn't even seen someone like me photographed and featured prominently in a magazine. Through drawing myself, I became familiar with the unique curves and slopes of my features, and with every stroke of charcoal over the paper, I felt as though I was stroking my own face and giving myself the love that I clearly craved. At nineteen, I was a long way from the country in which I was born, but still not quite at home in the country where I grew up. For me, home was a place to remake within myself, and part of that process was learning to love myself.

The young people in this book came to this country older than I did. They remember what their former homes looked like, how they felt, who lived there, or still lives there, and whom they miss. They have more of an original identity than I did at their age. At the same time, they are learning how to live in a new country, adopting its language, culture, and customs, changing the culture even as it changes them. Sometimes people treat them like they don't belong here. They, too, must love themselves when others won't. While their new country debates a border wall, a Muslim ban, and restricting immigration from poorer nations, they are growing home inside themselves.

Somewhere between a good photographer, a good listener, a simple backdrop, and the help of several co-conspirators, a space was created to represent this moment in their lives. And so they stand facing the camera, and this country, with grace, humor, sass, and gravitas. They expand how our imaginations visualize the words "immigrant" and "teenager" and help us see the world as it is—diverse, complicated, and much bigger than the sum of our own experiences. They challenge us to expand our notion of "we" and "us" beyond our own borders, to take in the greater experience of being a human alive on earth. They share their precious memories of a home that was and their yearning for a home to be, and in that intimacy create a space for all of us to grieve, to reflect, to hope, and to act.

Thi Bui
Berkeley, California
February 2018

Homecoming

I am the granddaughter of Jewish immigrants from Germany, Russia, and Poland, and the daughter of New York–born parents who did not speak their own parents' first language. I spent my first formative years in the Northern California mountains, away from television, electricity, and other media. Though I was U.S. born, pale-skinned, and a native English speaker, when we moved to the city I was often asked, "What *are* you?" and "But where are you *from*?" Perhaps because of these experiences and perhaps because I live in a country with a long history of both stigmatizing and absorbing other cultures, I've always been most interested in questions of belonging and homecoming.

Oakland International High School (OIHS) sits in North Oakland, just a few blocks from my childhood home, at the crossroads of a neighborhood that was once largely Asian-American and African-American and now, like many parts of Oakland, has a significant white middle-class. OIHS is one of twenty public schools in the country founded specifically to welcome immigrant teenagers from all over the world and is home to 390 students from over thirty different countries. Students have access to English as a Second Language (ESL) classes as well as a more traditional high school curriculum adapted for English learners.

Most of these teenagers have come to the United States by necessity, often leaving not just their physical homes and possessions, but their most loved ones as well. At OIHS, they have a home base, a place where they can be seen as the teenagers they are—concerned with sports, fashion, crushes, and the best selfie angles as much as with questions of navigating basic needs and trying to find a future path. Here, they do not need to constantly explain what they are or where they are from.

I first visited OIHS a number of years ago as a volunteer for their Career Day, to talk with the students about what is involved in writing, editing, and publishing books. When I asked these students how many had read a book, they all raised their hands. When I asked them how many of them had read a book that reflected their experience, only one student raised her hand. One of the books I brought to share with them was by the Zen monk Thich Nhat Hanh, who was born in Vietnam and exiled after the Vietnam War. We began talking about the idea of home and how we can carry our homes with us.

This project grew out of our conversations about what is belonging and what is home when it is, by necessity, not a physical space. Ericka McConnell shot the photographs during lunch, at recess, and after school. She shot in the courtyard and in the library, as people were milling about, shouting and playing. These are, deliberately, not formal portraits but images of these teenagers as they were most comfortable, alone or with friends. The stories alongside the portraits were taken from short interviews done in the same settings. Almost all of these interviews were conducted in English, which was none of the teenagers' first language.

Thich Nhat Hanh asks, "Do you have a home? You may go home each night to a house or an apartment. But do you have a true home where you feel comfortable, peaceful, and free?"

He continues, "Even if people occupy our country or put us in prison, we still have our true home, and they can never take it away. I speak these words to young people and to those of you who feel that you have never had a home. I speak these words to the parents, you who feel that the old country is no longer your home but that the new country is not yet your home, who see your children suffering, looking for their true home, while you have not yet found it for yourselves. A true home is what I wish for you."

Our hope, in creating this book, is to remind us that we all deserve to be safe, to feel at home, and to be seen for who we are.

Rachel Neumann
Oakland, California
March 2018

Portraits

Sliem Fikadu
age 18 / Keren, Eritrea

Back in Eritrea, I used to sleep with my sister. There were six of us siblings and we slept two by two, me and my sisters together and my brothers together.

My house back there was beautiful. I really miss it. We used to grow our own tomatoes in a big yard surrounded by a tall fence. Back home, I had a lot of time to play and hang out. School got out at 12:30 in the afternoon and then I could go play soccer with my friends. We would play all afternoon together. We had a lot of time for fun.

In the front of my house, we had a store that was full of all kinds of little things that people needed. We bought and resold soaps, needles, and anything you needed.

I've been in the United States for four years. Our house here has two rooms, just like back home, but the rooms are very small. I share my room with my sister again. It's hard to find houses in Oakland. I don't really like where we live because we don't have our own space or outside space. After school, there is no time or place to play. I just go home and study. My dad works, and my sister is busy, so I am often alone.

When I leave school, I want to have a good job and a big house so I can live my life however I want to. I want a garden so I can play there and spend time just enjoying myself. If I have the opportunity, I'd like to go back to my country. I would live in the same house we used to live in, because it is still our house and no one lives in it. I don't know if it will feel the same, though. If it doesn't, then I don't know where home is.

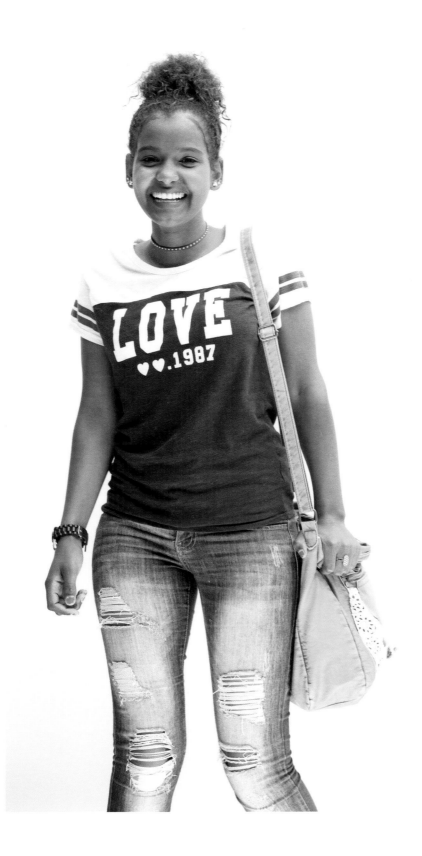

Eh Hsa Say

age 18 / Karen State, Burma/Myanmar

I grew up in a Thai refugee camp. Our family didn't have a lot of money. My father was a miner and he had to struggle to find work. The work was very difficult for him and also very unhealthy. He coughed a lot, but he had to do it for our family to survive. We stayed in a house with him and me and my mom, but my mom was very sick. Every day, my father had to go to work, and most days my mother was too sick to get out of bed. There were many days when no one took care of me.

Now I live in a two-room apartment in Oakland. I share a room with my sister.

Home for me would be feeling safe. When it is raining and I have a place to be that I know that the rain won't get in and nothing can get me, then that would be home.

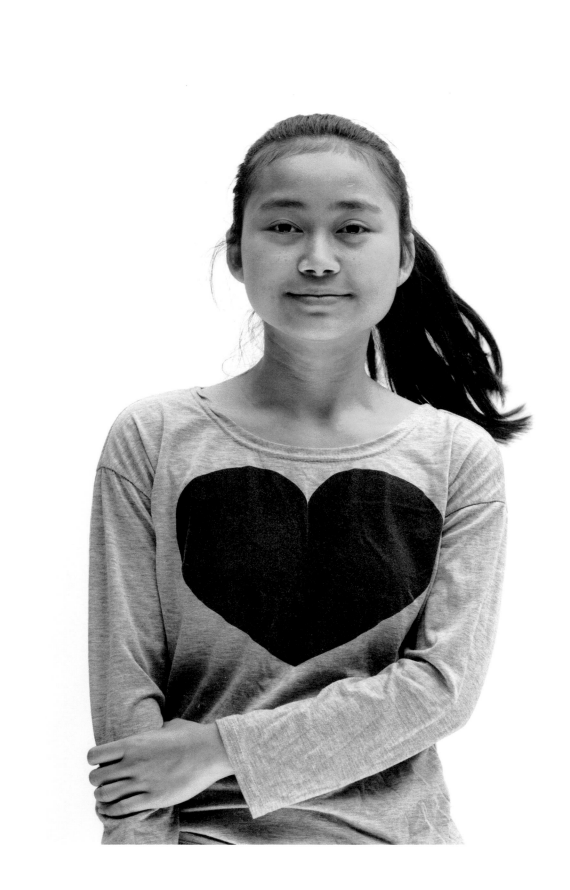

Haseen Mohammad

age 19 / Kabul, Afghanistan

I grew up in Kabul, the capital of Afghanistan. I lived in my great aunt's apartment. There was a big yard behind the building. We were seven brothers and two sisters, plus the grown-ups, so we were eleven people all living together. All of us liked to play together. After school, I studied hard so I could learn English and math. But then, when I was done, I could go play soccer with my friends.

Now I live in Oakland with my parents in an apartment. There is another family that lives on top of us. We have a little back yard, so that is good. After school, the people I play around with now are my little brothers who also live with us. One is seven and one is ten. This is home now: here, in the yard, with my brothers.

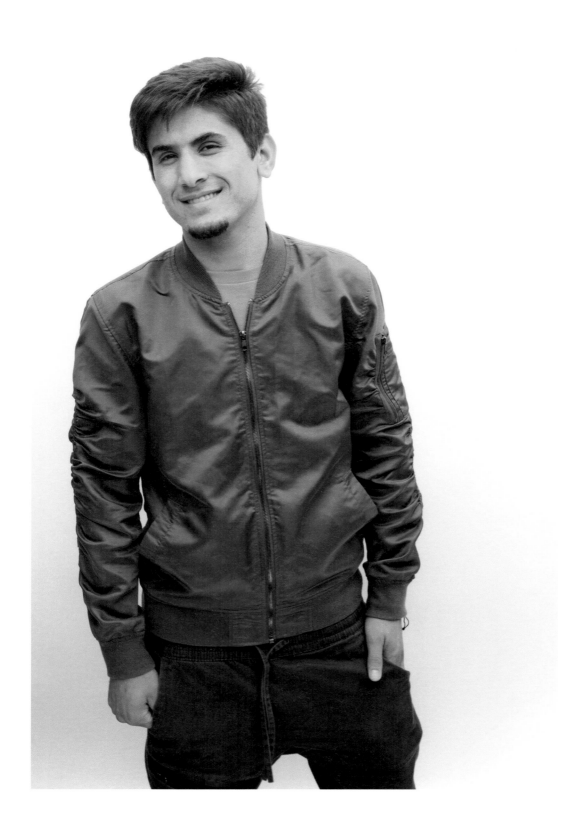

Marta Lima

age 17 / Sanarate, Guatemala

In Guatemala, I lived with my mother and my brothers and a lot of animals. We had dogs, parrots, cats, horses, and many cows.

Now I live in Oakland, with just me and my mother. I have some uncles here and two brothers in Guatemala. We don't have animals or a garden; it's quiet. When I think of home, I think of everyone being together, the whole family and all the animals there in Guatemala.

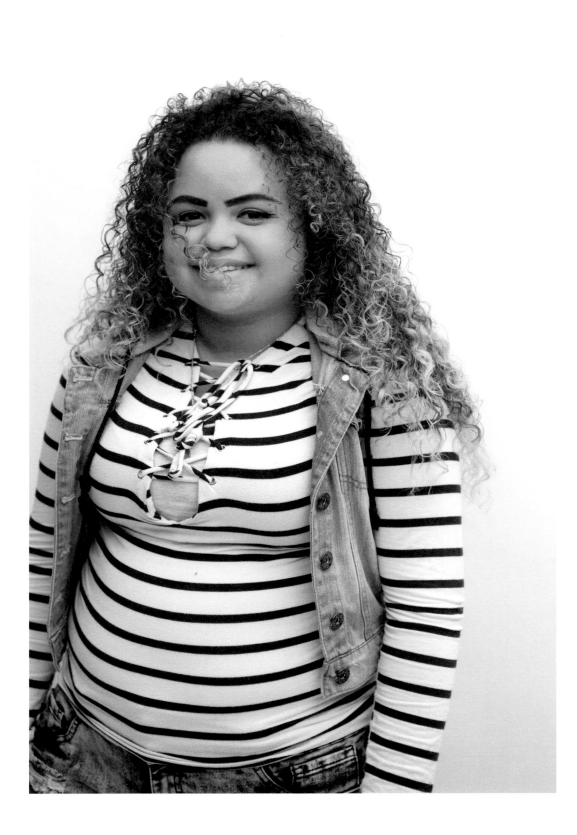

Suzana Tesfu
age 15 / Adi Keyh, Eritrea (left)

Merhawi Tesfu
age 19 / Adi Keyh, Eritrea (right)

We lived in our own house in Eritrea. We were a family of eight. It was safe, but my father wanted us to get a better education. He got us student visas and we went to India for school. We lived in Pune, near Mumbai. We went to school for five years there, and then came to the United States with a visitor visa. We were awaiting asylum. Our whole family came, except one brother and one sister who is married.

We live in Oakland now. We live with our mom and siblings. We live in a nice place, and it's pretty safe there.

Home is a place of enjoyment with your friends, a place where you can go out of your house at 6 a.m. and come back at 6 p.m. and be safe.

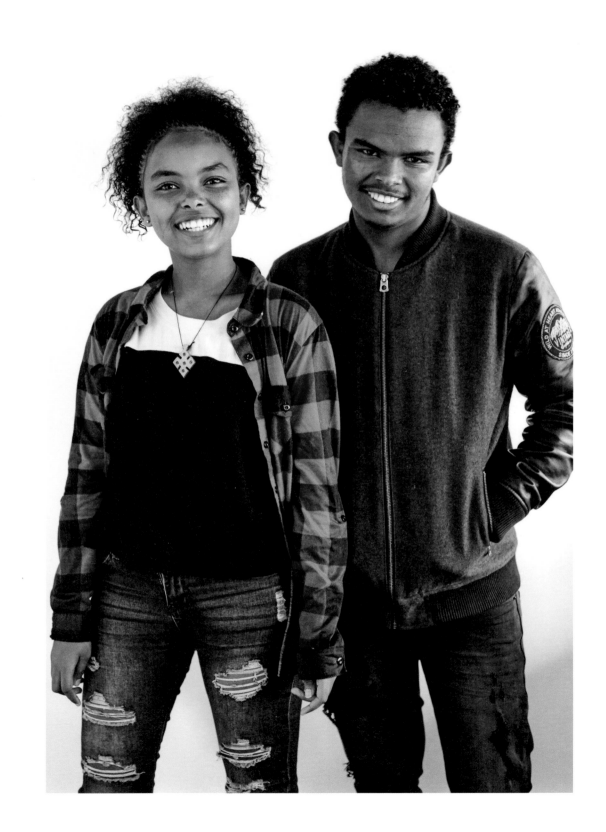

Najiba Mahdavi

age 21 / Rural Afghanistan

In Afghanistan, our house was pretty small, but it wasn't too small. We had one room. All of the kids were little, though, so we liked being in one small room together. It wasn't a problem.

We had a big yard full of flowers and trees. It was so pretty. If I wanted space, I could go into the yard. Our house was far from town. If you wanted to buy soap or paper or anything you needed, you had to walk twenty or thirty minutes. I had some friends, but they lived far away so I didn't see them often. I had one sister and two brothers, so that is who I played with.

Now my home is three rooms. It is bigger than my old house but we are bigger, too. We live on the second floor. It is okay, but we don't have a yard. That is something I miss. When I woke up in my old home, I smelled flowers. But here I don't smell anything. If I smell anything, it is because it smells bad.

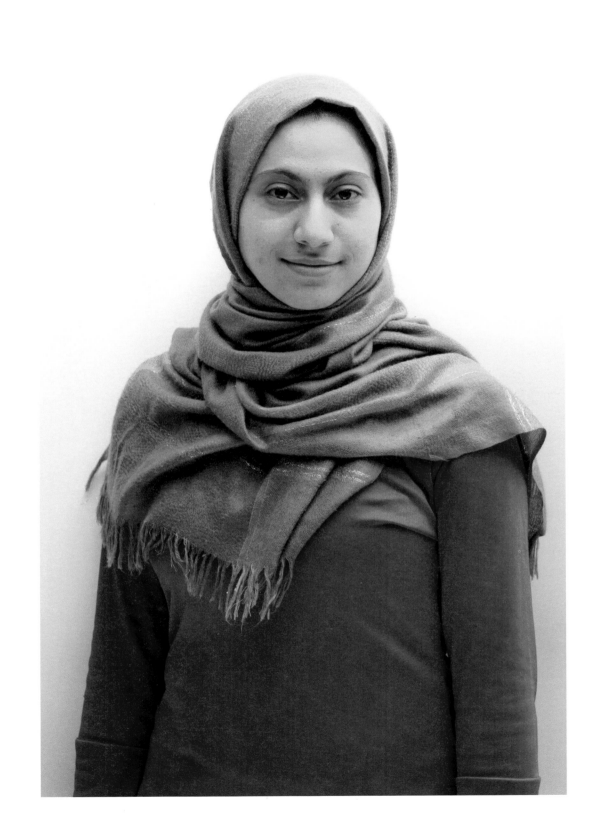

Hardy Rolando Miguel Maldondo Macario

age 16 / Quetzaltenango, Guatemala

I grew up in Quetzaltenango, Guatemala. It's a little town that showed the poverty in Guatemala. Some people there lived outside without a roof. Some people had a roof but no walls so you could see into their house. I lived with my grandmother, my uncles, and my cousins. A different family branch lived in each room. When I think of my childhood with my cousins, we always had fun. We'd take a bottle of water and use it as a football. We'd play hide and seek. Sometimes I'd use my money to use a computer at an internet cafe and explore the world outside. I didn't imagine I would live outside Guatemala one day.

I came to the United States when I was thirteen, three years ago. I came here with my younger brother, but my other brother and my sister had been here for twelve years already—I didn't know them well. I'd only spoken on the phone with them a couple times. The first day, my little brother hugged me. My mom always told them about me and showed photos of me to them, so they knew me, but I didn't know them. I tried to hug him back.

Where we live now is so different from my old house. I like that we can have family time around a table, instead of all being in one room all the time. Home for me is not about a particular house. Home is where you can find happiness by staying with the people you love, where you can have good communication, and get a good feeling from being together. Where we live now everyone works all the time and we don't have time to be together, and so there's less of a feeling of home.

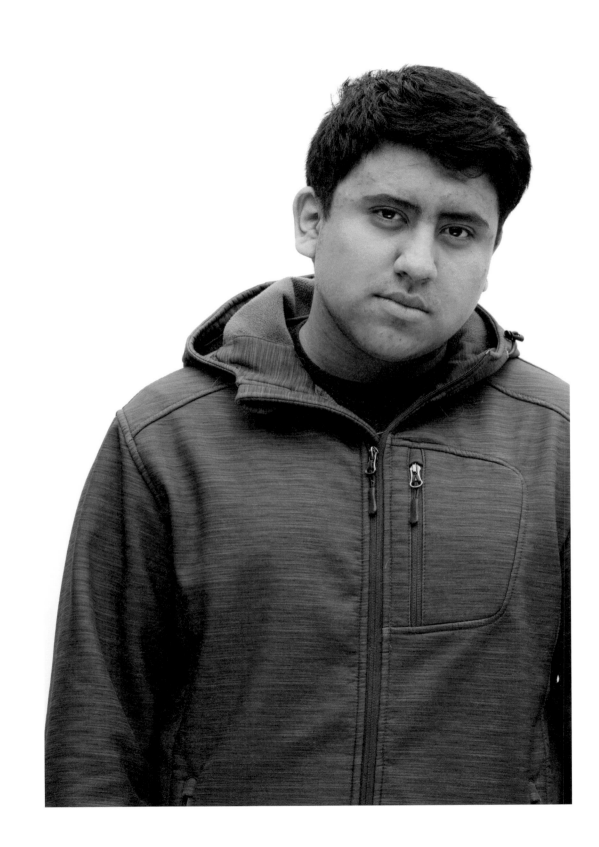

Salahuddin Sarwari

age 17 / Kabul, Afghanistan

In Afghanistan, I lived with my family, my three sisters and one brother, with my uncle and cousin in the city. When I was very little and it was safe, I would be outside, playing with my friends.

It was not usually safe where I lived. There were bombings and killings everywhere. When we went to school, we were very scared just to walk to school; there was too much violence. Often, we would just stay home and not go to school because it was not safe to go out. Because we had to stay in our home, we only saw each other, and could only play with each other. It was too dangerous to go outside.

We all came to the United States on the same airplane. I like it here because I am safer. I can do work and go to school. It is better here. After school I hang out with friends and sometimes watch basketball. When I first came here, I didn't know any English, but when my English got better it was easier to make friends. In the beginning I would learn two, three, four, five words every day.

This is a good place, a good home. In America, you don't have to think a lot and you feel safe. In Afghanistan we had to think a lot about everything. Oakland feels more like home to me than Afghanistan. It's most important to me to feel safe. To me, this is home.

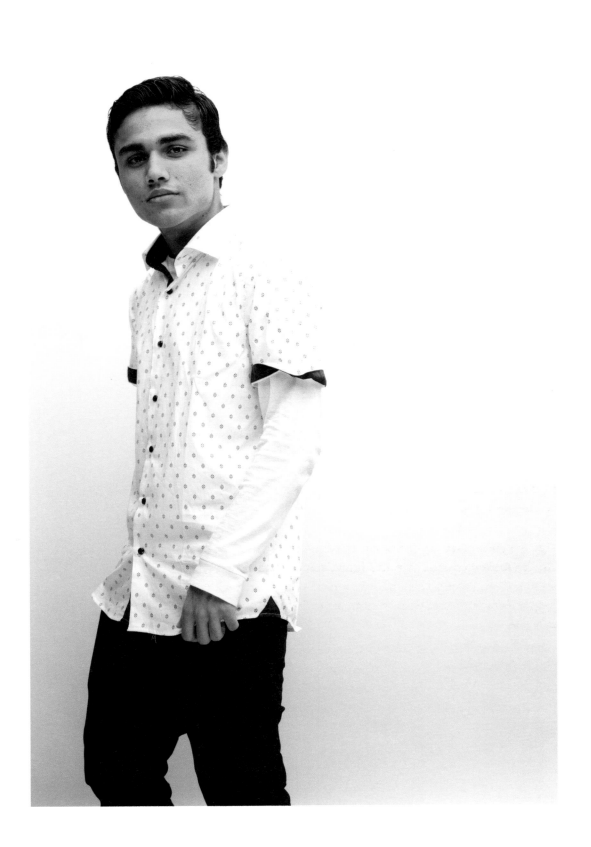

Luis Aguilar

age 18 / Tala, Mexico

I grew up in a dry place, kind of like a desert. There was no asphalt or paved streets, just rocks and earth. It was surrounded by mountains. I lived with my father, my mother, my sister, and my two brothers. There were six of us in the house. We were two houses from the river and I would go and play and take showers in the river. My school was far away; it was a forty-minute walk. In the morning it was okay, but in the afternoon it was very hot, and I would walk home and sweat a lot. Then I would clean my house, and in the back of my house I could play soccer.

I was fifteen when I came to the United States. The house here is a little small—in Mexico it was two stories, but here it is just one. The room is a little small. In Mexico, I had more space. The streets here are bigger than there. Here there is so much asphalt and so many cars. In Mexico it was very noisy, and here it's quiet. I miss the noises because I want to play music very loud, but that is not done here.

My mom came here first when I was thirteen, and I lived two years with just my father in Mexico, who worked the whole day. So I had to take care of my little brothers. My sister was fourteen, a year older than me. My mother came to visit us, and she took us back. One year ago, only my father was left in Mexico. There was a problem with documentation. Now my father is here.

When I think of home, I think of Mexico, and children playing games in the street. I think of the coolness of the place, not too hot or too cold, the forest over there, the fields. This is more like the city, kind of like Guadalajara. Fruitvale kind of reminds me of Guadalajara.

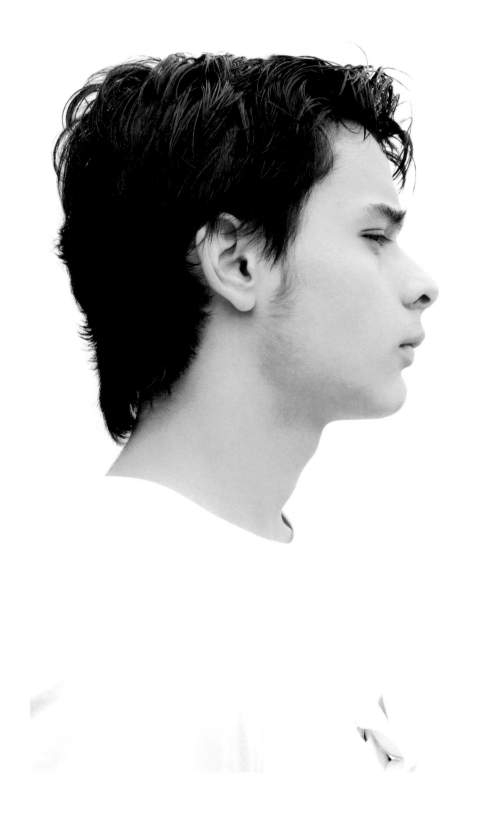

Maritza Bernal

age 17 / Las Vigas, Mexico

I come from a small town with a lot of people. When I was little, the town was little, but as I grew, the town grew, and now it is getting too big. There were a lot of animals in the city. Every day I would see dogs, pigs, and chickens. I had to walk through thick grass and I would see snakes right outside my house and I could hear them all the time in the grass. My parents would say that they were not that dangerous.

We had two houses: one in town, and one where we kept the animals, the chickens, dogs, and pigs. I liked the country house better. It was more beautiful and more lively.

Almost four years ago we moved to California. We live with my cousins. There are seven kids all together, so it is always loud. From my window I can see a McDonalds and a police station.

When I think of home, I think of my home in the country with the animals.

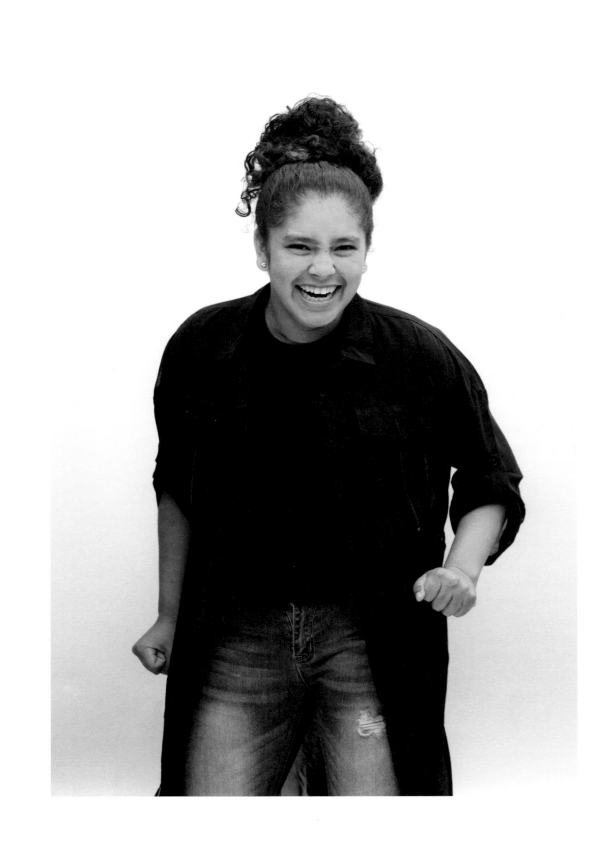

Anna Akpawu

age 16 / Lomé, Togo

As a child, I lived in a small house in the city with my mom, my little sister and brother, and my cousins, who came and went. At night and on weekends everyone would come outside their house and hang out, with people dancing and chatting and kids and grown-ups all playing together. Every morning, you could just wake up in the morning and talk to your neighbor until you got tired and went home. Everyone cared about each other.

I came to the United States when I was twelve because my dad wanted me to have a better education. In my country, you can go to school, graduate, but even if you get the best grades and the highest degree, it is hard to get a job.

I want to do something in the health-care field because I like helping people. I'm not scared of blood. You know when you get hurt, some people say to drink your own blood, so you don't waste your own blood. I'm pretty okay with that. When I was little, I saw a car accident where a car hit a person on a motorcycle. I still think about it and wish I could have helped. It's funny how bad things that happen to you stay in your mind and get stuck there. But happy things that happen to you can go away in your mind—they don't go all the way away, but they fade.

Life is worrying here, especially if you're African. African parents are very strict about everything because they want you to do your best. I can't remember the last time I got to hang out with my friends. It's just school and homework, not even any television, just studying. On special occasions we get to pick what we want to eat and I always pick pizza. I actually don't like fast food but I do love pizza.

For me, home is a happy family. Home is where there are people that care about you and where you are safe. Where people need you in their lives. It could be anywhere. Preferably with pizza.

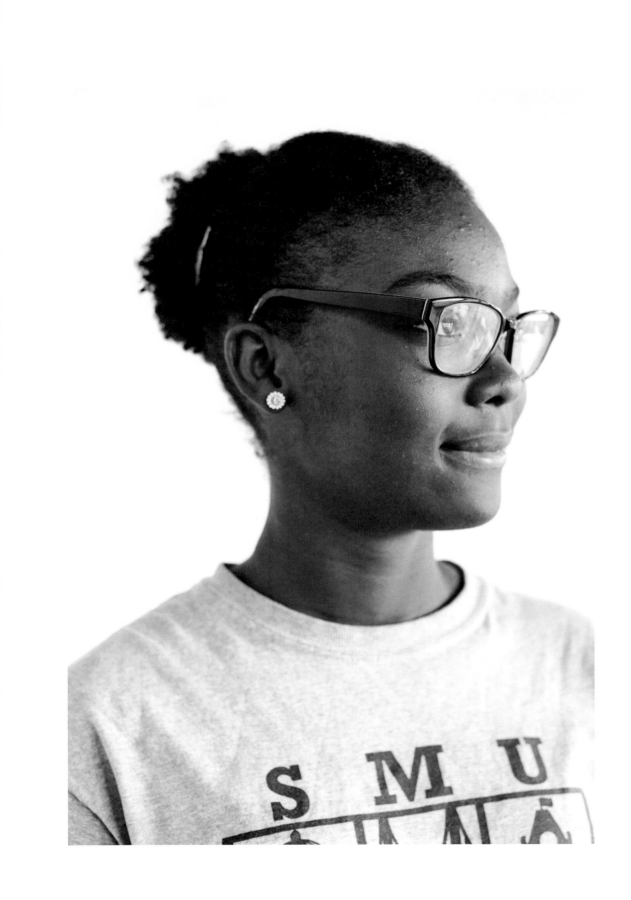

Abdulmalik Alshugaa

age 18 / Ibb, Yemen

I used to live with my big family, twenty-five people, including all my cousins. Everyone had to leave Yemen, but they all went to different places. Some went to Egypt, some to Saudi Arabia, and my family came here. We all had to leave because we wanted a better life.

We wanted jobs to help our families. Everyone from our family left. There are some people who were homeless who now take care of the house we used to live in and take care of the animals we had to leave there. Maybe one day some people from our family can go back.

I am already applying to college. I like computers, so maybe I will major in computer science, but I'm not sure.

Now I live in a small house, two rooms. I live with friends here. My mom and sister and brother recently went back to Yemen. After school, I work until 10 p.m. at night. I work in food delivery. It's a good job for now.

I don't know where I would live in Yemen. It's more dangerous now. I can't go back— I might get killed because I lived in America. Oakland is the best. This is my second home. When I go to Los Angeles for even three days, I miss Oakland. I feel like I am in my home now. This is now my home country.

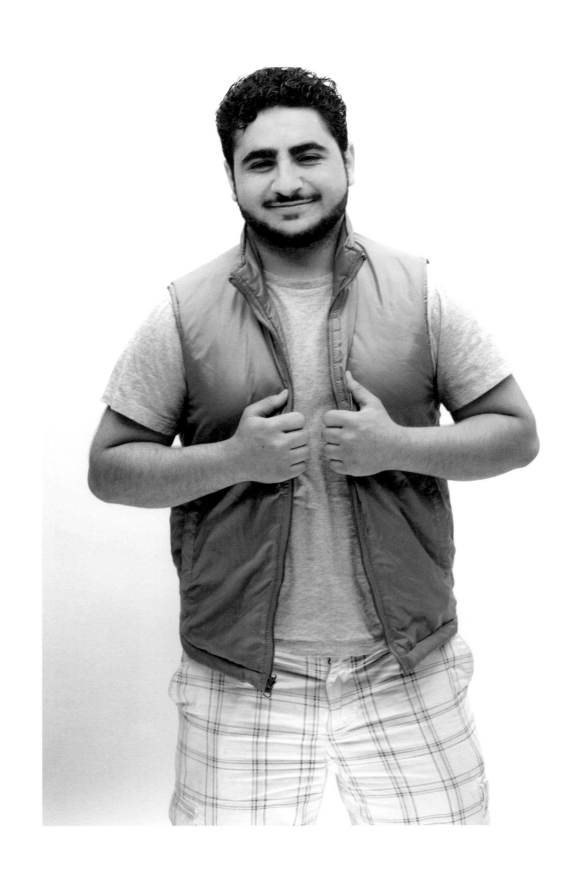

Sathusha Pasupathy

age 16 / Kuala Lumpur, Malaysia

I was born in a big and crowded city. My family had a store that made clothes and bags. It was really crowded and so hot! There were so many tall buildings. The city was not that clean but it was clean enough. It was loud because we were in the business center and there were lots of cars and people there. Our house was kind of far from the city, so it was more peaceful. In the city the houses were very small and the people in the city had a lot of tension. There were always fights in the city.

I liked that the work was in the city and the house was just a little way away in a quieter place with just me, my brother, and my parents. I had a dog, Jimmy—I think he was a kind of bulldog. He ran around the house. I miss him so much. He was thirteen or fourteen years old when he died. He was with me from when I was small until I was twelve or thirteen. We buried him soon before we left to come to the United States.

Now I live in an apartment with my parents. I can see the lake and our home is quiet inside even though outside it feels more like the city.

Back home there was more calm around me. Here it is louder.

When I think of home, all the sounds and memories come together in my mind from back home and here, mixed together.

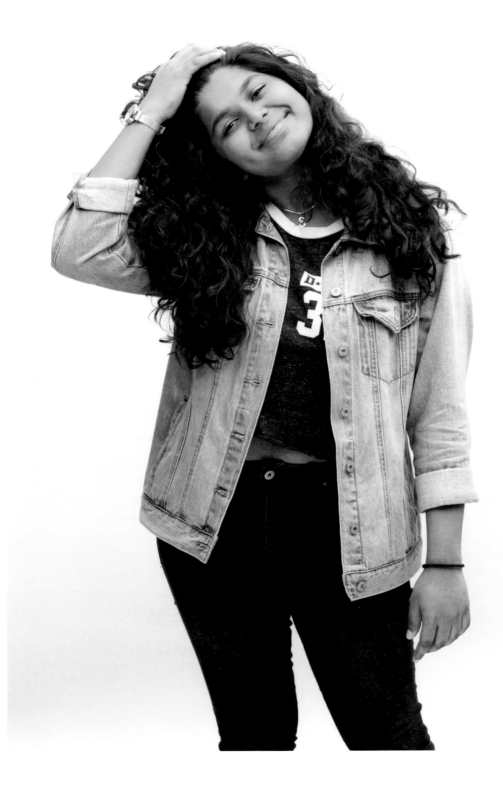

Silvia Jeronimo Matias

age 19 / Todos Santos Cuchumatán, Guatemala (left)

Juana Martin Pablo

age 18 / Todos Santos Cuchumatán, Guatemala (right)

My father told me I was born in a small house, and there was nothing else around. After I was born, my family moved to another town where there were more things happening. We met new people. My parents and my little twin brothers and I all shared a room together. I liked how I shared all my stuff with my brothers. I am the oldest.

I came to the United States in 2013. My mother came first. We stayed in Guatemala for two and a half years without her. After that, she was able to get papers for us to come. I was happy and sad to come. In Guatemala I have a lot of family. Here, I have my parents and my other siblings. I have the feeling of wanting to be in both places.

Honestly, it doesn't feel like home to me here. In Guatemala, there are different things to do. There, you can go out whenever you want. Here, I have to stay in more and I can't just walk around. I work every day after school. In Guatemala, we made our own clothes. Here, we go to stores and buy what we need. It's different.

When I think of home, I think about my house where I grew up, and how nobody is in it now. I would like to be there.

I grew up in Guatemala, in a small town, near a forest. There were not a lot of people living there. It was far away from the town where we could buy food. I grew up working and planting vegetables, like carrots and onions, just so we could feed our family. I lived with my mother and my young sister. After school, the expectation was that, as a woman, I would make my own clothes, feed the sheep and cows, and start to cook food for dinner. The whole town was very green, beautiful, and clean.

Now I live in a house with my whole family in Oakland, with a lot of people of different races. My father was here while I was growing up. I came to the United States five years ago. I like Oakland. I like to know different kinds of people.

A home is a place where you can live on your own. You have your own house; you can do whatever you want. You can plant whatever you want. You don't have to live with other people. Other people can do good things or bad things if you live with them; you are not in control. My home is here, in the United States, because my family is here and my friends are here.

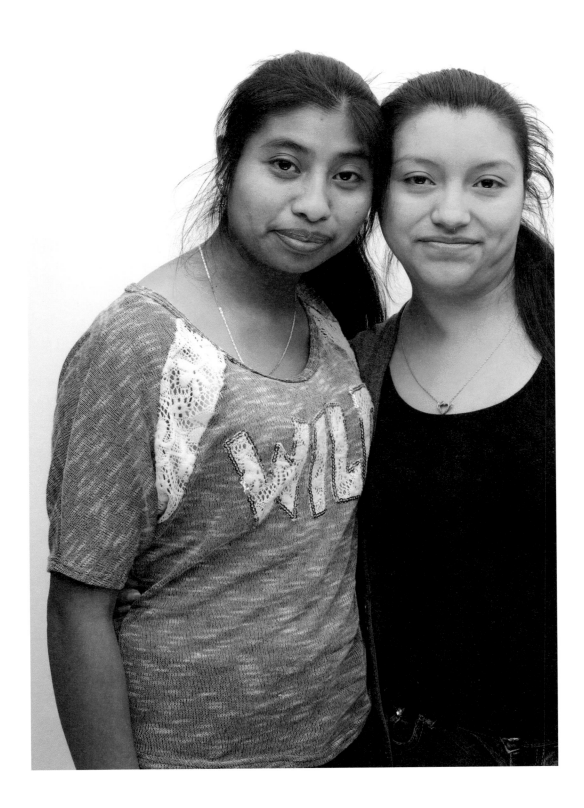

Pablo Rodriguez

age 17 / Pénjamo, Mexico

I first crossed the border from Mexico into the United States when I was nine months old.

We lived in Arizona until I was six, and then we went back to Mexico because my mom really missed it. It was a good decision, because it was great to get to know my family, but I had to keep starting my life all over. When I was here I didn't know Spanish, but when I was there I didn't know English. When I was six and they told me we were going to Mexico, I was like, what is that? I came back to the United States when I was fourteen.

From six to fourteen, I lived in a village that was near my grandfather's ranch. I could actually enjoy life there; it was relaxed, not just a full-time hustle. I didn't live on the ranch, but I went there all the time to help my grandpa. I lived with my family and I got to know how they lived, what kind of foods they made, a whole different way to live. School in Mexico was tougher, more strict with more homework. Still, it was more relaxed in some way. Here in school it's all about studying, having a career, and working. That's it. Over there I felt like I learned more about all of how to live my life.

I came here because my brothers were born here, and because my mom is here with my stepdad. I focus on school, working, and studying. There are a lot of white people here. There are different holidays here.

Since I was twelve years old, I've thought a lot about home. I'm here now, and I hope to make enough money to go back to my village and build my own home and retire there and live with no worries. In Mexico, it is harder to get money, but people really value what they earn. Overall, there seems there is more appreciation for life back there.

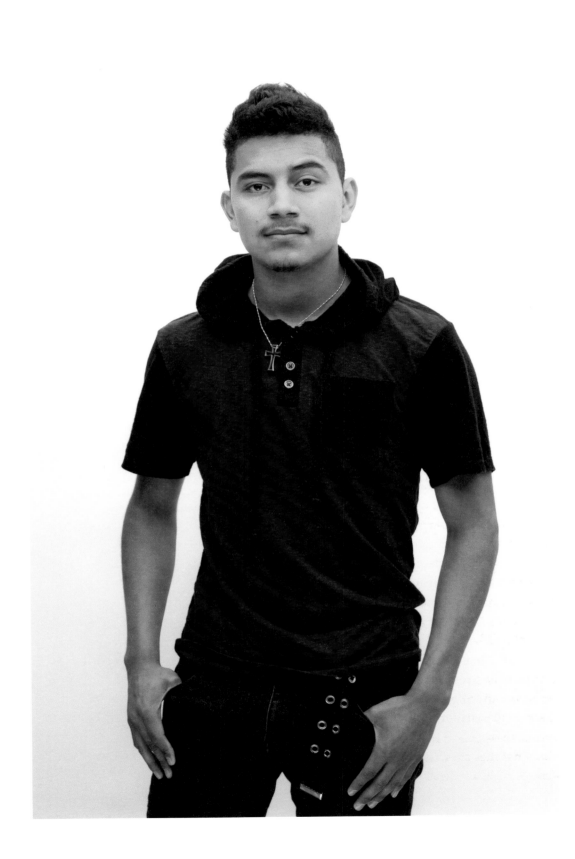

Oumou Thiane

age 17 / Dakar, Senegal

My country is Senegal. I like my country because there are so many people there. I like the food—it smells so good. In my country we always eat rice, meat, and fish. I come from a big family. I live with my mom, my sisters, and my brother here in the United States. My dad is here as well but my parents are separated.

In Senegal I lived in a big house with my grandma and my mom's mother and father. My mom's father had three wives, and many cousins, sisters, brothers, and aunties. We had many trees and a garden. Chickens, cows, cats—we had a lot of animals in my home. Looking out the windows you would see people walking and many trees and cars going by. There were a lot of children around because my grandma taught classes. She taught children how to write and speak in Arabic. Wolof is our home language.

Here I live with my mom, sisters, and brother. My sister and I lived with my dad for one year. There were problems with my dad, so my mom came. My mom and sister are working. My mom came to help me and my sister. My dad has four wives and has a lot of problems. He yells at us. I don't want to talk to anyone about my problems, but my friends say I should talk to someone. I do all the homework for my sister, brother, and my mother.

Home is my family. I think of my beautiful house in Senegal. I think of my friends, my grandma, and the food. I miss my grandma. I think of my future in nursing to help people who are sick. I want to have a house in Senegal and a house here.

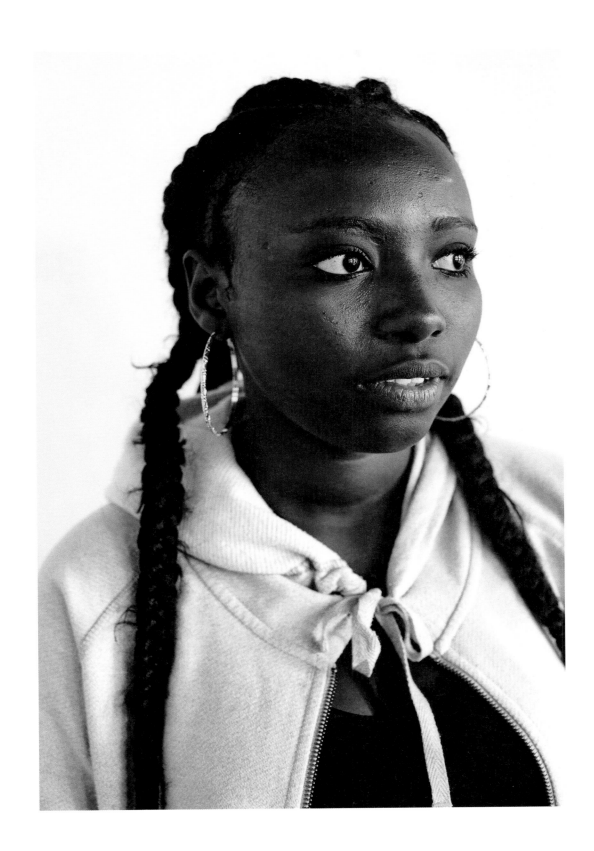

Asma Alawadi

age 18 / Ibb, Yemen

Ibb is known for being very green. It's really beautiful—I miss it. I remember the mountains and the water. There were a lot of rivers that I would swim in when I was a little girl with my family. We used to go camping in the mountains.

I used to go with my dad to work. He worked at an office with police officers, and I liked to go and hang out. I used to go out with the other officers and drive around with them. They used to let me practice and play around driving their car when I was just ten years old. My dream was to be a racecar driver. The other officers knew that, but my dad didn't know. I told them not to tell. They told me I needed a different dream for myself, but they still let me drive the car.

Now I live in Oakland. I live next to a calm neighborhood. I hate the smells. It makes me sick sometimes. It's not really a smell, but a feeling. It's sadness. I came here to see my grandma, because I hadn't seen her for twelve years. But I don't love it here. I miss home. Most of my family is here, but I liked living over there. It was more fun. I know where to go, what to do when I'm there. I miss nature, too. I used to go out all the time, I never stayed at home. But here, you just go to school, you go home.

For me, home means safety. That's it.

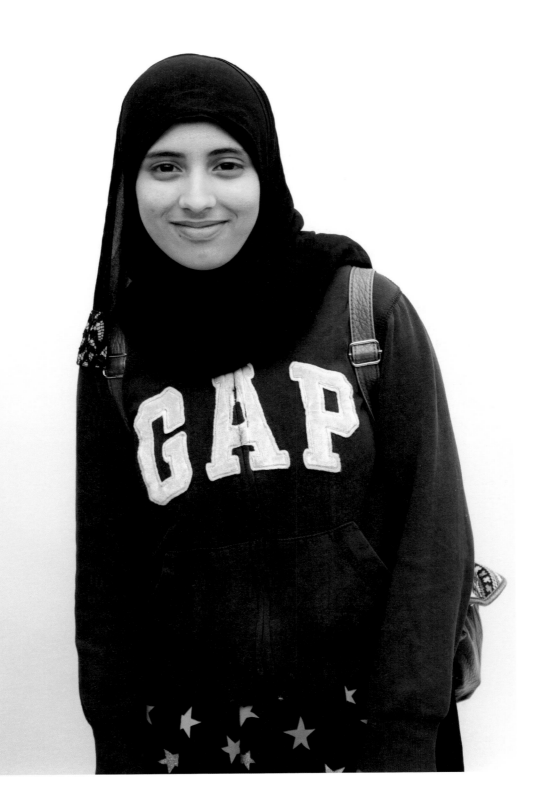

Heidy Hernandez

age 17 / Sanarate, Guatemala (right)

I lived with my grandmother and my brother in Guatemala. The country was beautiful. Sometimes it was cold and sometimes it was hot, but it was always comfortable. People were nice to me because they were family, or they knew my family. The food was delicious.

Where I live now, on San Pablo in Oakland, it's always cold and windy. I don't talk that much with my neighbors, but it's a calm place. There are places that I can go nearby to play.

When I close my eyes, I can feel safe and loved wherever I am. That is home.

with **Karla Vides Perez** (left)
age 18 / Cojutepeque, El Salvador

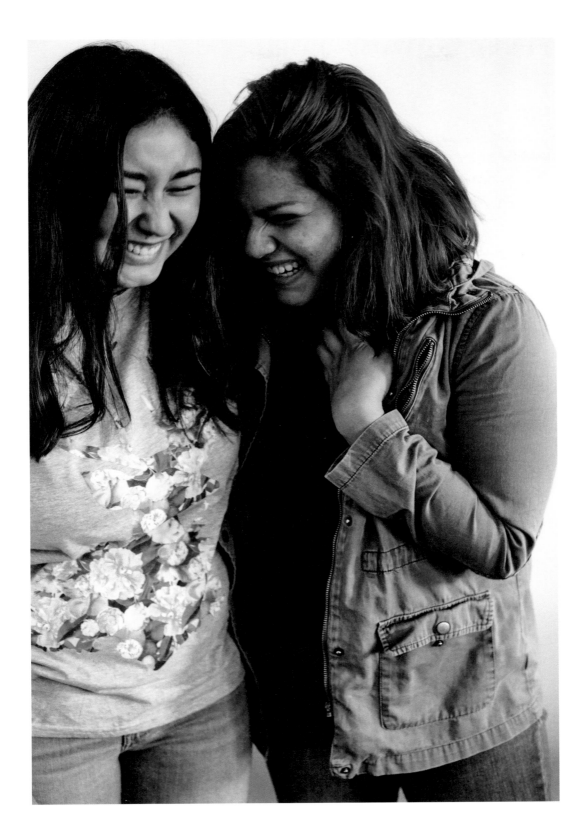

Abbas Mahdavi

age 16 / Kabul, Afghanistan

I lived in Tehran when I was little, but I was born in Afghanistan.
When I was a kid, my family moved to Tehran. It was a good city.
I was a baby, maybe six months old, when we moved.

I lived with my whole family: my father, mother, sisters, and
brothers. I have two sisters and one brother. Mostly the people
around were Iranian, but in the neighborhood where I lived
there were many people from Afghanistan who moved to Tehran
to make a better life. The languages are similar, and so are the
cultures. Afghans speak Dari and Iranians speak Farsi, but we
can understand each other.

I came to the United States when I was thirteen. We live in an
apartment with my whole family in Downtown Oakland. My
parents work, and it's a safe place. I like it. There's another
Afghani family on the same floor as us, so that's cool.

I think of home as any place with my family that's safe. Both
Tehran and Oakland are home.

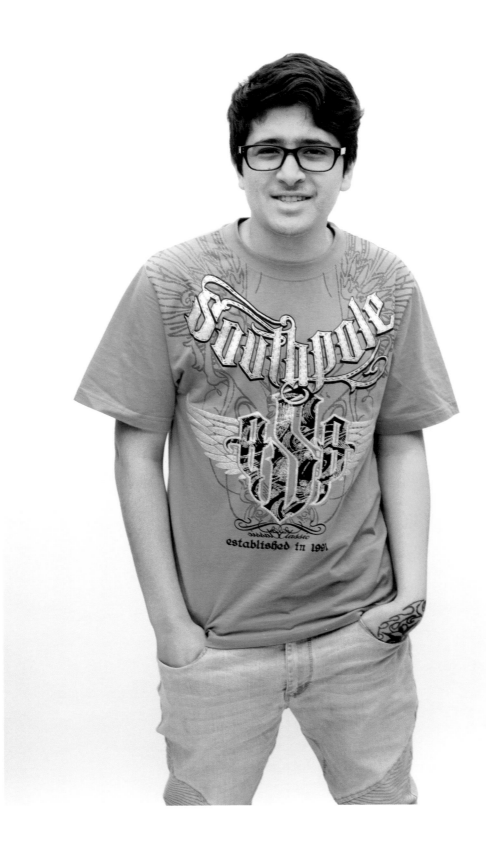

Luis Martinez

age 19 / San Vicente, El Salvador

I used to live in a small house made from concrete blocks on the top of a little mountain. When I was twelve, we didn't have regular running water. The water came every Tuesday through the pipes for two hours. Sometimes it wouldn't come. We had a tank to save water. There were trees all around and we cultivated the hillsides. When it rained, the electricity would cut out.

I lived with my grandparents. I have sisters and brothers but I didn't live with them. My dad left for the United States when I was four. I had no memory of him; I had just seen him in photos. When I was in El Salvador, my family was focused on me going to school to be successful. Now my dad just needs me to work and only talks about work.

I had two choices in El Salvador: live with my grandparents and be happy but not successful or necessarily safe, or come here and live with strangers and have a better future. I didn't want to come, but my grandparents told me to come here to have a better life. I only had two days' notice that I was leaving El Salvador. I didn't get to say goodbye to anyone except my grandparents and, quickly, my mom and other siblings.

Even though I didn't live with my mom, I saw her every day. I would walk the cows and collect the water to drink from the spring. Where I live now is completely different. I live with people I have just met, my stepmother and dad and their kids. The street is loud and not very safe. We live in a house with a dog, a cat, a bird, a turtle, and some chickens.

In the house here, we have water, electricity, and as much food as we need. In El Salvador we sometimes had limited food.

I think of home as a place where I can have peace, I can share my opinion and my feelings, and I can get support.

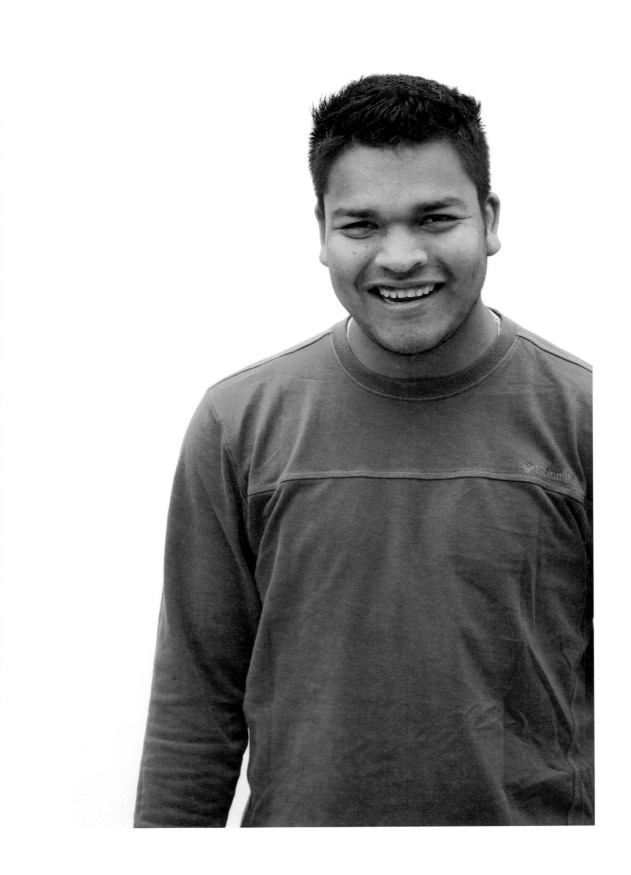

Laura Jeannette Chavez Martinez

age 20 / San Salvador, El Salvador

When I was five years old, I lived with my parents, my grandparents, my great grandmother, and my two brothers in a very big house near a little forest. Outside there were chickens and children playing. There were so many kids.

After that we moved to the city, San Salvador. When I was a child, it was easy because I didn't know what happened outside my home, or what was happening with my neighbors. I just played with the other kids. But as I got older, I saw that there were a lot of guns there. Every night I heard a lot of gunshots. It felt dangerous. Soon, I couldn't walk outside at night. My grandmother didn't like me to go outside. Sometimes it was okay to go outside for a little while during the day but not for long and not all the time.

My mom was in the United States, and she would call me whenever she could. We would always talk to her on the phone. I would come home right after school. Often, I would sit in our big and beautiful garden. It was full of all kinds of fruit, oranges, guavas, and mangos, and it smelled really really good. I came to the United States two year ago. There are a lot of cars in our neighborhood. Sometimes the neighbors come in and out of the cars, but they don't play outside.

The air here is so different than where I grew up. Maybe it is because the trees are different. The air in El Salvador was so fresh. My grandparents and great grandparents are still there. I want to visit them but I can't.

I like being with my mom here; I missed her. I feel safe here. The only thing I don't like here is the food. I feel different here. Wherever my brothers and my mom are, I think of as my home. My home is any place where I am safe with my family. Right now, that place is here. Maybe if El Salvador changes I could live there, but not now.

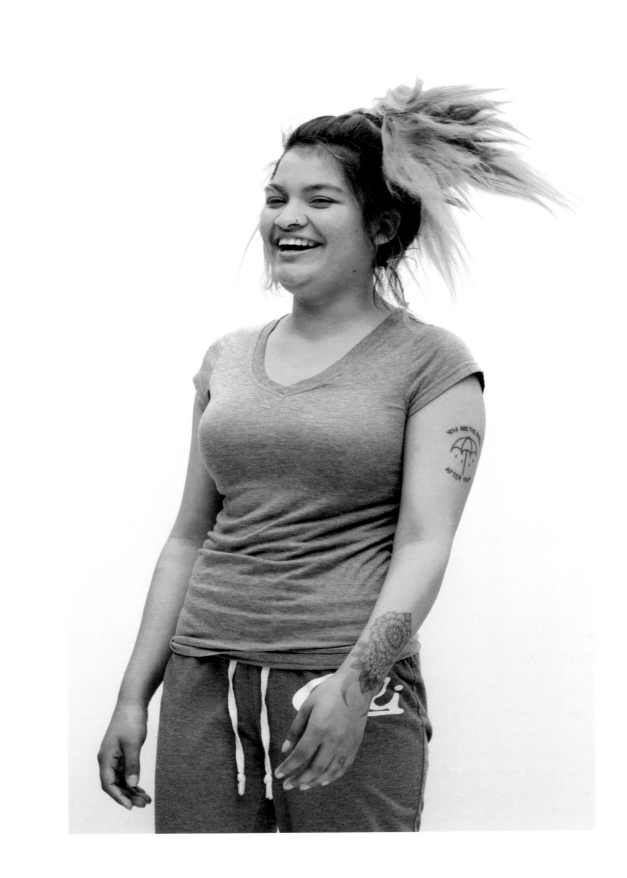

Hser Tha You Say

age 17 / Thailand Refugee Camp

I am from Burma but I was born in a Thai Refugee Camp where I lived with my parents and three siblings. My brother wasn't born until we moved to California.

We had one room where we all lived and slept with my parents. The house was quiet in the morning. It would still be dark out and we would all get up and get ready for work and school, not talking. After school, I would go to the forest and find food and swim in the river. I cut tree branches to make firewood. Then, in the evening when we all got home, it would be so loud, everyone talking and returning from the day.

I came here five years ago. Now I live in an apartment with my parents and siblings. We sleep in different rooms and the evenings are quieter. I share a room with my sister. After school I go home and do homework for my college classes. If I don't have college classes, I go to soccer practice.

Because we were refugees, I have lived a lot of places. But I don't know where my home is. I haven't found it yet.

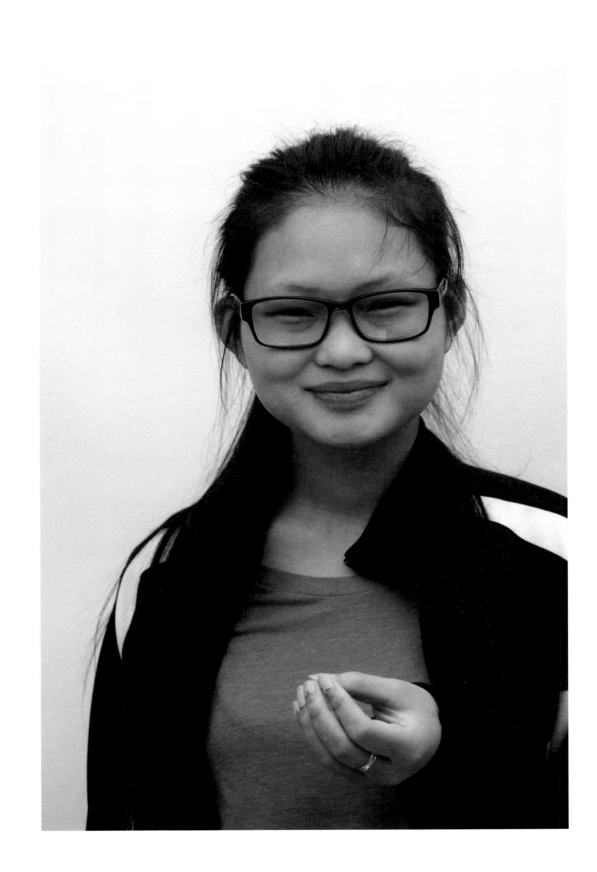

Mohamed Almakrai

age 18 / Ibb, Yemen

I came to the United States when I was twelve. My dad was already here. Before we came, I lived with my mom and grandma and my aunties in a big house with my own room.

My grandma used to grow coffee plants. I got to drink coffee made from them. The school was right next to my house. I didn't like it so much. Mostly it feels like Yemen was a long time ago.

Now I live with my mom and dad, and my brother and sister. We have a garden here, too. But we don't grow coffee, only flowers.

I like living here more. It's more home for me.

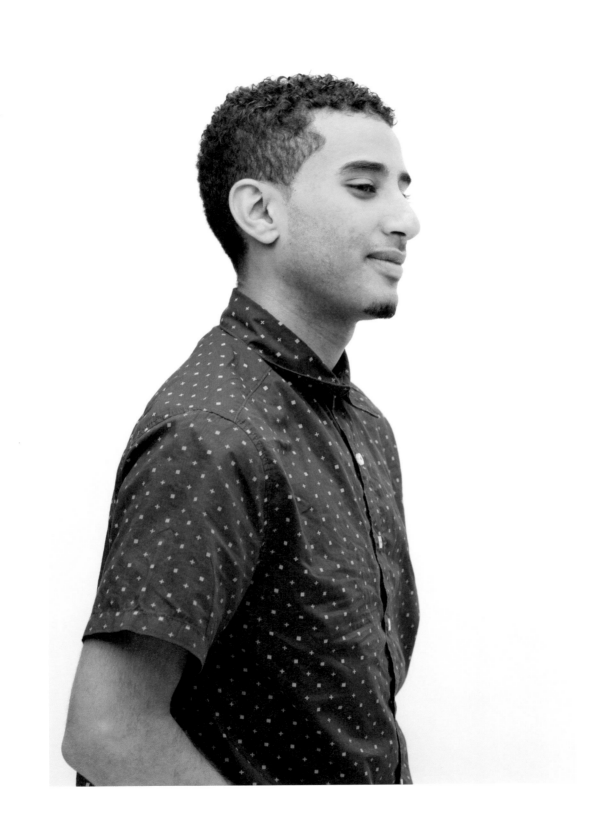

Hamzah Al Alshoghaa

age 18 / Sana'a, Yemen (left)

I grew up in Sana'a, in the Hadda neighborhood. It was a good neighborhood. People there were not rich but not poor. It was a safe place until I was thirteen. Then a war started inside the city, and people got killed. I came to the United States when it got dangerous, with my brother and sister.

Right now I live in Richmond. It's a safe place. The difference between this life and my last life is that here where I go to school, I'm safe. I don't need anything.

I think of home as here. It is safe here and it is easy to get an education and get a job.

with
Saqr Abdulla (center)
age 17 / Sana'a, Yemen

Ahmed Eluflihi (right)
age 17 / Sana'a, Yemen

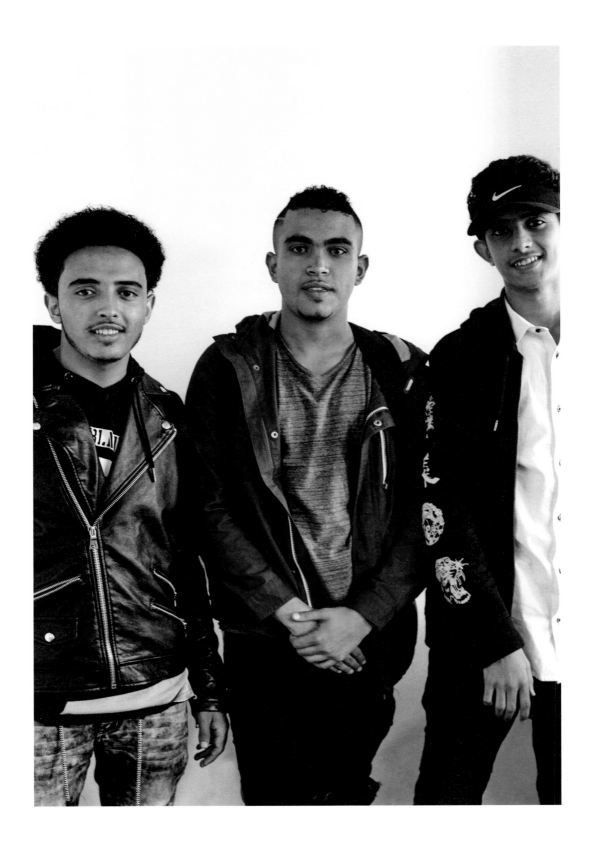

Jose Martinez Herrera

age 16 / San Salvador, El Salvador

I lived with my mom, sister, and brother in El Salvador. My house was big, in the city. I saw trees. The house was behind a park. I played with my friends in the park or the streets. We played soccer and tag. I feel sad when I think about my house because I don't have my mom here. I miss my friends and my brother.

It was very dangerous there. I worry about my mom and brother. My brother didn't come here because my uncle didn't have enough money for all of us to come, so just me and my sister came. I miss my mom the most.

I don't see anybody outside the windows in Oakland. I just see cars drive by. There is nobody walking by, and no trees. My sister and I cook. We live with my uncle. Here we live in a big house, too.

I feel hella different here. In El Salvador, when school was over, I would go home, eat, do my homework, and then go outside and play with friends. Here I don't have friends to play with, and I can't go outside because my uncle is too worried about my safety.

I feel most safe with my friends in El Salvador. Even though El Salvador was too dangerous, I felt safer there.

Home is my family, my friends, and everything I miss.

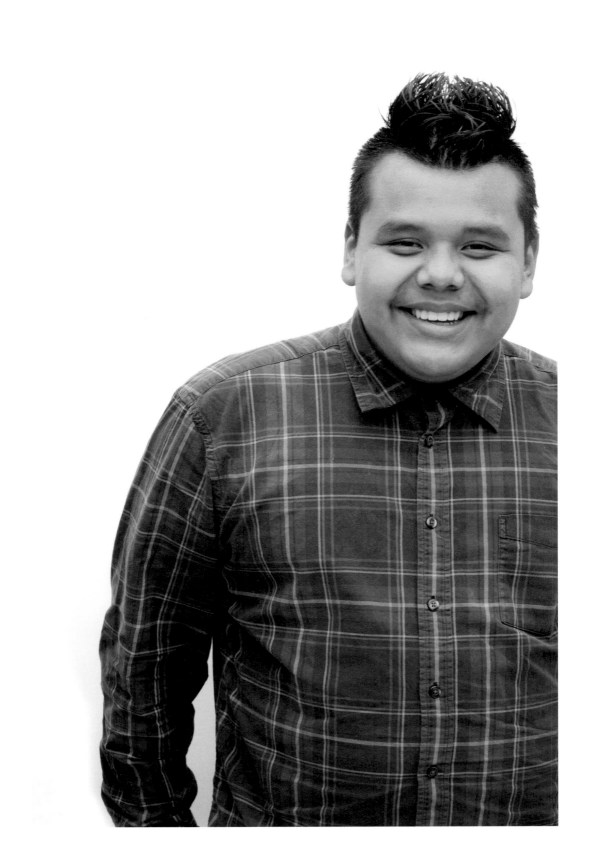

Kamela Dris

age 19 / Tizi Ouzou, Algeria

When I think of Algeria, I see a lot of buildings. A lot of autos moving, a lot of sounds, yelling, horns, and beeping. A lot of women coming back from buying at the market. Smells of bread, the women preparing food for the kids when they get home from school. I lived with my parents and my sister.

Here it's smaller; you feel like you're holding your breath because it's so small. We can hear the neighbors; in the apartment you can hear a lot of sounds. But no smells—nobody is cooking. There's a lot to do here. In my country, there isn't as much.

When I think of home, I think about a big house, where my whole family lives, a lot of happiness, movement, a good life.

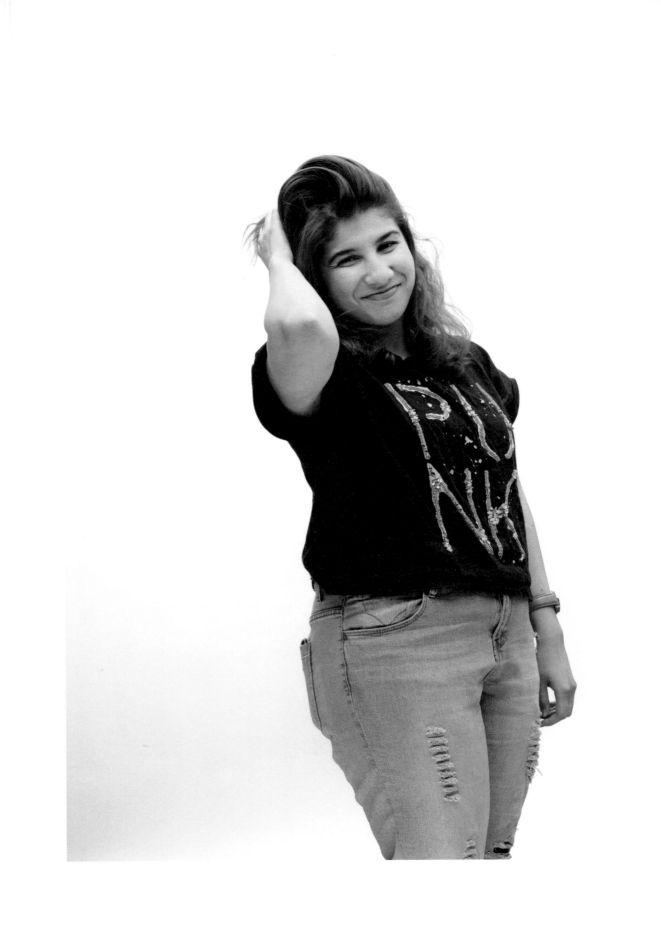

Leidy Jimenez

age 19 / Marsella, Colombia

I used to live with my grandma, my mom, uncles, aunts, and cousins in an old, big house. My grandmother was always cooking something that smelled good. In front of our house there was a cemetery but there was also a big sidewalk where people could walk and sit on benches. On one side of the house there was a park. The park was filled with mango trees and birds. Our family would walk along the path in the park and greet everyone as they walked by.

In Colombia, all the trees have a lot of green and leaves. Our town was small, no movie theatre and not many cars, so people were always out on their bicycles or walking.

Now I don't feel the warmth of my family. Outside my window there is a tree but it's not a beautiful tree. It has just a few leaves. Sometimes I hear birds but the trees are sparse. Mostly, I just see cars; I don't see people walking, kids playing, people greeting each other. Here my bicycle sits in the basement.

Love feels like home, being together with family—not just everyone for themselves. Home to me is the sound of good conversations. I still think of Colombia when I think of home.

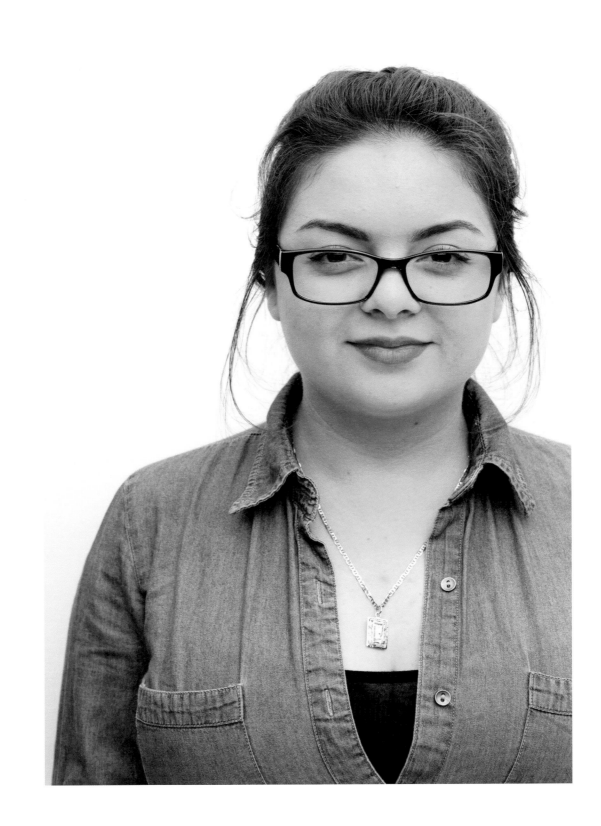

Jhonatan Gonzalez

age 18 / Guatemala City, Guatemala

Guatemala City is a big place, but I lived in a small house. I lived with my brothers because my mom went to the United States to have a better life. My brothers and I came to the United States a little over a year ago. I liked the food in Guatemala; I love tamales, pepián, chechitos, and empanadas. My brothers are nineteen and thirteen, so I'm the middle brother. My grandma and my aunts are still in Guatemala City.

Now I live with my brothers and my mother in the United States. It's good—I feel happy because I haven't lived with my mother in ten years. When I saw my mother, I was crying. I was very happy and also sad. She was here in Oakland for the past ten years. She worked hard to get the papers so that we could get into the country.

I like living here, but when it was my first day here in this school, it was very different. I didn't understand anything in class. I started picking up the language, though, and I started to enjoy living here more. I like Oakland because it's different. It has some variety. Sometimes it's cool and sometimes it's hot.

When I close my eyes and think of home, I think of my family— my father, my mother, and my brothers—all my family, together and happy. It doesn't matter where we are. It just matters that we're together.

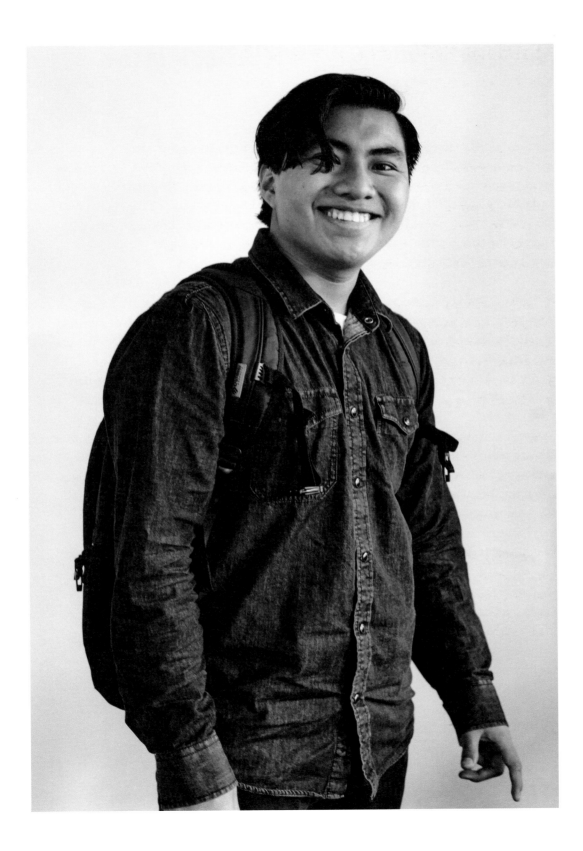

Nassar Korin
age 15 / Ibb, Yemen (left)

Ibb is a medium-sized city. I grew up in a neighborhood with my grandpa. I knew a lot of people there, people I grew up with and was with all of the time. I had more friends than I have here. The first time I came here was in 2014. I was sick back home. I came here to go to the hospital.

In Yemen, I would play soccer and some basketball. I was the only one who would play basketball, because my dad brought me one. I'm still in touch with my friends back in Yemen.

I live in Berkeley with my dad. I like Berkeley. Sometimes I go to my dad's store. Sometimes I go out with my friends, sometimes I play soccer, but I broke my finger. Over here is all about hustling and trying to build yourself. My dad is all about that, and he supports me in trying to build myself. Yemen is all about be yourself, be with your family, chill out.

My family is everywhere, all over the United States, and back home. When I first came to the States, it was very different. To grow up in the hood, to come here, it was different. Back home was crazy; we used to do crazy things. When I came over here, I saw all of this, I couldn't play around any more. Over here is all business. When I came here, my dad said to me: if you want to build yourself, you can build yourself; if you want to bring yourself down, you can bring yourself down.

Julius Htoo
age 16 / Mae La Refugee Camp, Thailand (right)

I am from Karen State in Burma but for the first ten years of my life I lived in Mae La, a refugee camp in Thailand. There were a lot of people. We didn't have much food. There was no work for the grown-ups. We went to school in the camp.

We moved to the United States when I was eleven. Here it is better. We have food, good food, and we have enough to eat for the first time. There are a lot of people around. I have friends here. It is safer here. The refugee camp was not safe. You had to be careful when you walked around.

I think of here as home. Here it is good. We have TV, internet, phone, and video games. We never had a phone or video games in the refugee camp. I want to keep living here but visit Thailand.

with **Muataz Saleh** (center)
age 17 / Yemen

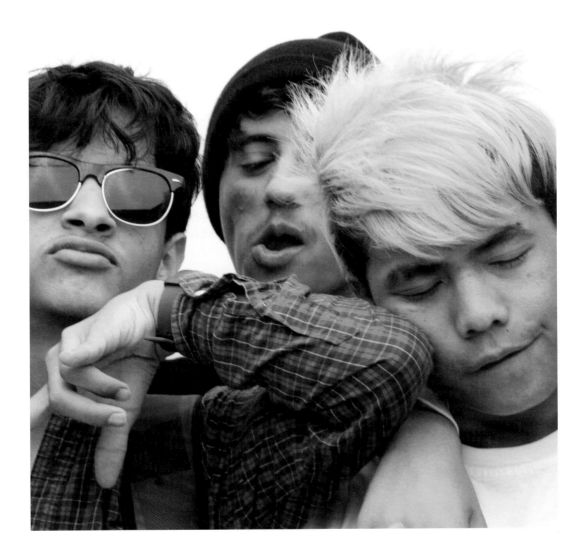

Haben Fikadu

age 15 / Adi-ghebray, Eritrea

I can see my mom working in the kitchen outside, I can see the birds, they come every day and sit in the window. Birds with many colors. We have three floors, our own house, it's beautiful. We play outside behind the houses. Near the well. We carried water from the well to the house. We had electricity and running water but sometimes they would close it, so we needed to get water from the well. We used the water from the well to wash ourselves. We would put the water in a large barrel and then use that for cooking, washing, everything.

We would see white people come and take photos but no white people lived in the town. But we had people from Yemen there. There was a church for the people from Yemen; every day they pray. We could see lots of stars; we could play at night. We had lights at night and we would play my country's games.

My dad came to the United States in 2003. I lived with my mom, brother, and two sisters. My dad left Eritrea because the government put him in the army to fight against Ethiopia, so he ran away. First he went to Ethiopia—he went in a truck; he hid in the truck with a lot of people. And then he came here in a boat. Once he made it to the United States he would send us money and we ate better.

In the United States we can see a lot more out the windows. I live on a busy street with lots of cars. We hear the police sirens too much. I live with my mom, sister, and brother. We often cook by ourselves because our mother is at church or going shopping with my dad. The boys learned to cook here; we didn't cook in our country.

When I hear the word "home" I miss my friends, my dog, my grandparents.

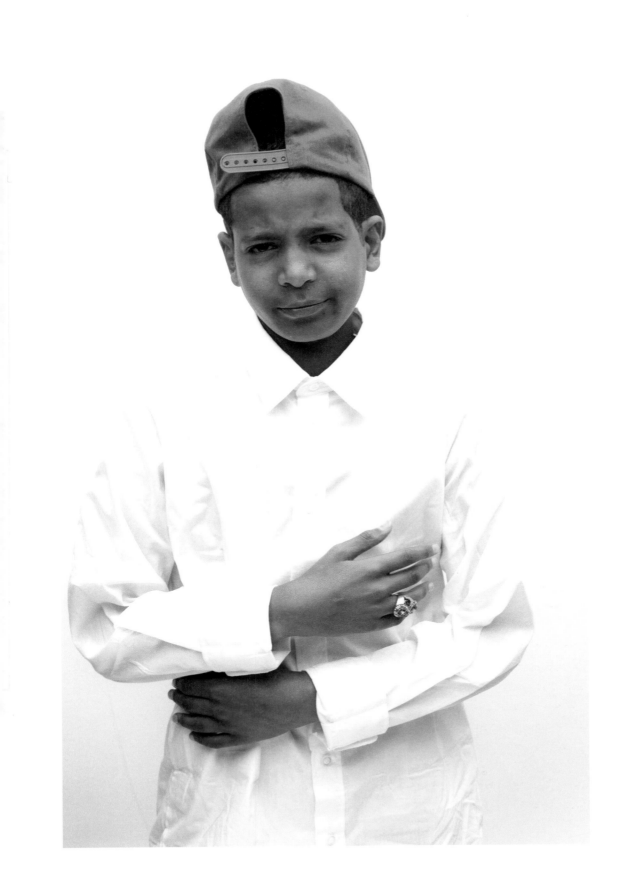

Neesha Magar

age 17 / Jhapa, Nepal

I grew up in a refugee camp in Timai. I didn't mind it. There were always a lot of people around. Even though it was a refugee camp, it was fun sometimes and I had a lot of friends. I shared my room with my sisters, one older, one younger, and my parents. There were a lot of other houses around my house. Everything was very close together and you could always hear what everyone was saying or doing around you.

I came here three years ago with my family. We live around a lot of Nepali people, a lot of cousins, so that feels like home. We live in an apartment that looks like a house from the outside. We have a garden with spinach, tomatoes, cilantro, and tea leaves growing. When I look out, I can see avocado and orange trees.

Nepal was more fun. There was less work to do; we went to school and came back. Now we are busy all the time. We work work work. My family is always tired.

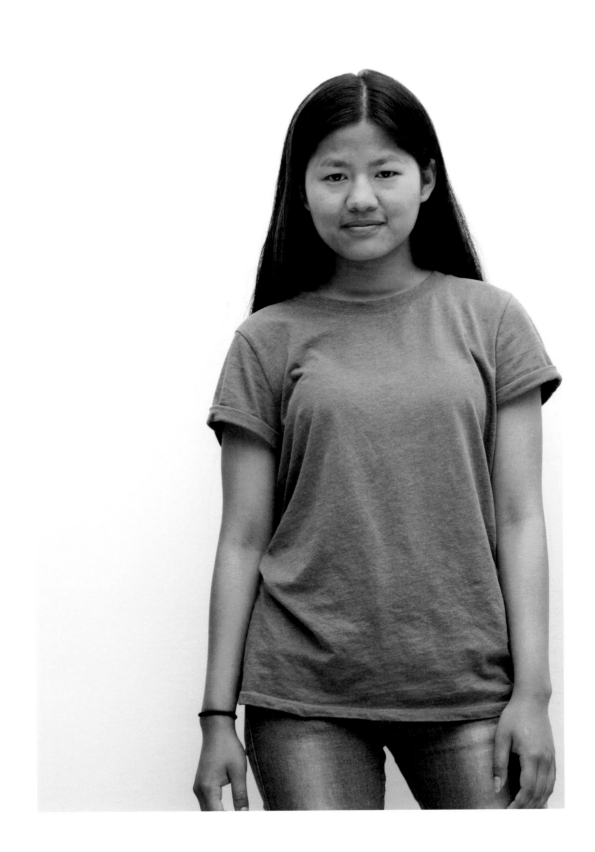

Karla Mendoza

age 20 / Todos Santos Cuchumatán, Guatemala

I grew up in a small town where the houses were made of red clay and there were many trees and animals. The mountains seemed like the biggest mountains in the world.

We lived at the base of the mountain and I could see it from every room in the house. I lived with my mom and my brother until he was fourteen and I was seventeen. As long as I can remember, my father was already here in the United States. I don't remember him ever being in Guatemala. My mom and I worked to make blouses by hand for the festivals. Todos Santos has a lot of festivals, especially in the winter. During November, people would come from all over the country for the festivals and the streets would be filled with horses and we would sell a lot of blouses.

There were no schools where we lived. To be able to go to school, I had to leave my home and family and live in the bigger town of Quetzaltenango, five hours away, with my uncle.

Quetzaltenango was alright, but I would always miss home. The wind in Todos Santos was very fresh. Everyone I saw or met was someone I could play with. There was time to relax.

Here, we are together and that is good. We have to go everywhere in a car and we have to stay inside during the day. Outside my house, I don't see mountains, only other houses. After school I work in a hotel, cooking for the guests. I don't have any time to play because when I am not at school, I am working or helping at home.

I think I have to return to Guatemala so the house there isn't sad and empty. My plan is to study hard and return, in five years if I can.

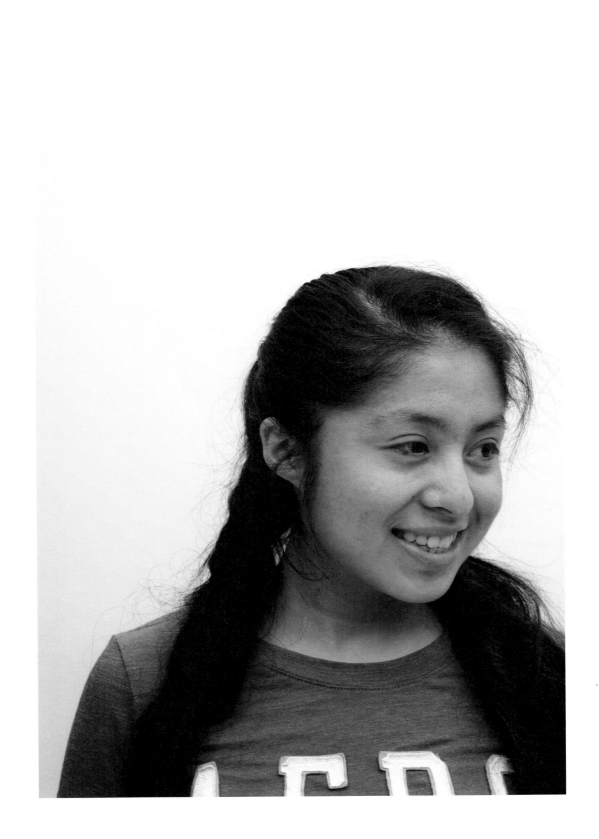

David Angel Chavez

age 18 / San Salvador, El Salvador

I lived in El Salvador most of my life, for seventeen years. When I was a child, I lived with my mother until I got sick and she came here to the United States. I went to five different schools from when I was in kindergarten to tenth grade.

For twelve years, I didn't live with my mom. I lived with my brothers and grandma. She protected me and helped keep me safe from violent gangs. I stayed safe by staying inside with my brothers.

I have been with my mother since May 11, 2016. Now, I live with my brothers and my mother, all together. I feel thankful that she remembered me and is now taking care of me. School is very helpful to me here. My English has improved a lot since I've been here.

I've only been able to talk to my grandmother one time. I want to know how she is and if she is safe. I want to stay here, but I love my home country, and I won't forget where I am from.

My home is here now, with my family. I love that people here are from so many different countries. I love all countries.

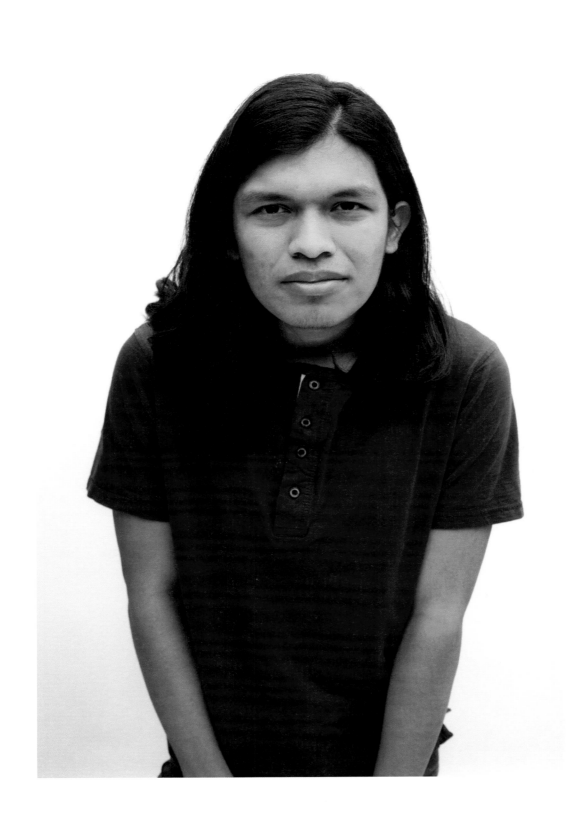

Bayan Al Rawas

age 15 / Syria (right)

In Syria, our whole family was together. We used to spend every holiday at our vacation home in a different part of Syria. I loved vacations and swimming with my family, all of us together.

We left because of the war. I came to the United States with only my parents and my siblings. The rest of my family is still in Syria.

We live in East Oakland. It's kind of crazy there but it's safer than my home country. I am very busy. I have soccer and college prep classes and music classes. I play the violin.

Syria was war and funerals, including my grandmother's funeral, and a lot of shooting. I try not to imagine our home because I think it is destroyed already.

with **Maryam Alhabbal** (left)
age 16 / Damascus, Syria

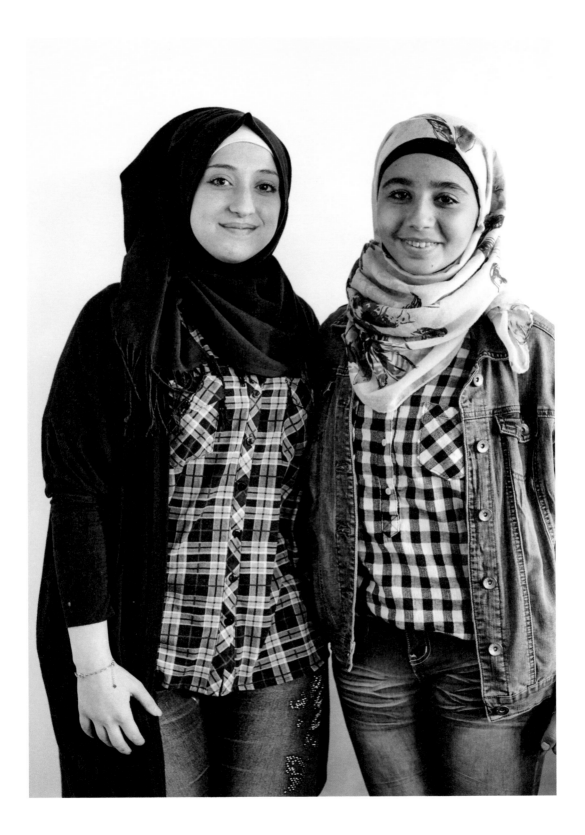

Daniela Ayala

age 19 / Mejicanos, El Salvador

I used to live with my grandfather. He took care of me and my older sister and brother. My grandfather didn't know how to cook and so he used to just give us chips and juice for lunch. Then he learned how to cook. I appreciate what he did for us: learning to cook and taking care of us so my mom could study. My mom was young and so she was studying in the university, and so my grandfather took care of us. She didn't finish school because she wanted to take care of us. She was so close to graduating, but she didn't finish. She made the decision to take care of us instead.

My mom made sure we didn't forget my dad, even though he was here in the United States. My dad called us every single day. I never felt I didn't have money even though we lived in such a poor country. My dad didn't forget us; he always sent us money. Now that we are here, though, it feels like I am losing my family. My parents are divorcing. My mom moved in with her twin brother. My sister moved in with her boyfriend and my brother is leaving too. But I think God knows my purpose in my life.

When my dad prepared the legal papers for us to come here, he wanted to make sure we wouldn't be separated from our mom. When I was younger I didn't understand, but now I understand that they can't be together. If they don't love each other, they shouldn't be together. They both found other people that make them happy, and that makes me happy because they have the right to be happy. My dad did not treat my mom well. I hope he learns to treat people better so he does not end up alone as an old man like my grandfather. But that's not my business—I can't be in the middle, fighting with both my parents.

I feel good here because here I feel safe. This school makes me feel good and safe.

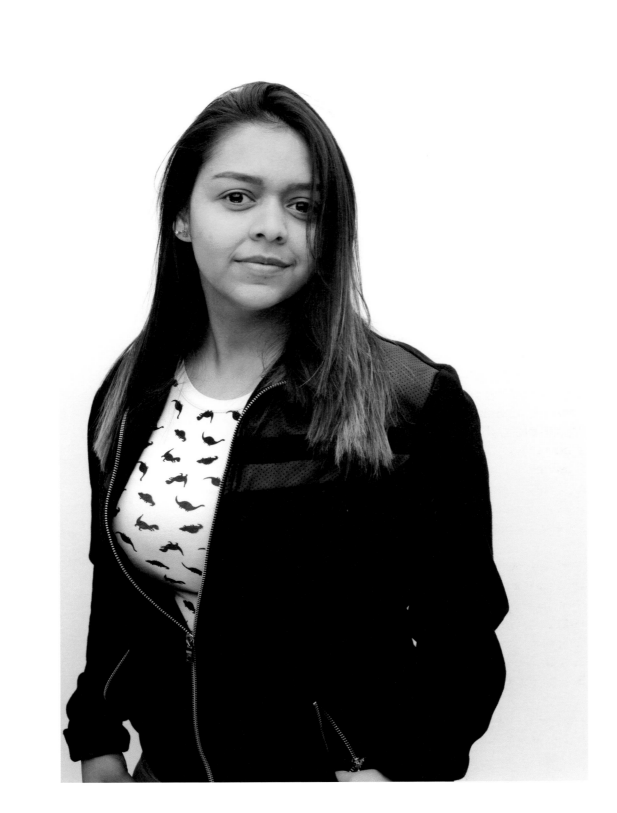

Jorge Fuentes

age 18 / Sonsonate, El Salvador

My house in Sonsonate was surrounded by a lot of trees. We didn't have any cement or pavement, just ground and rocks. My house was painted bright green, and behind our house was a river. We had a bus stop right down the road, and every day I would take the bus to school.

After school, my friends and I would go on walks and just eat and talk. There were places we could walk to where you could play games and rent computers, and we would go there and play video games for an hour or so before we had to head home.

Now I live in a gray and white house. We have a big space in the front where we garden a little. We have a lot of dogs in the back.

My mom and dad are with me and there are friends in the building, but my brothers are not here. Until we are all together, my home is there, with them, in Sonsonate.

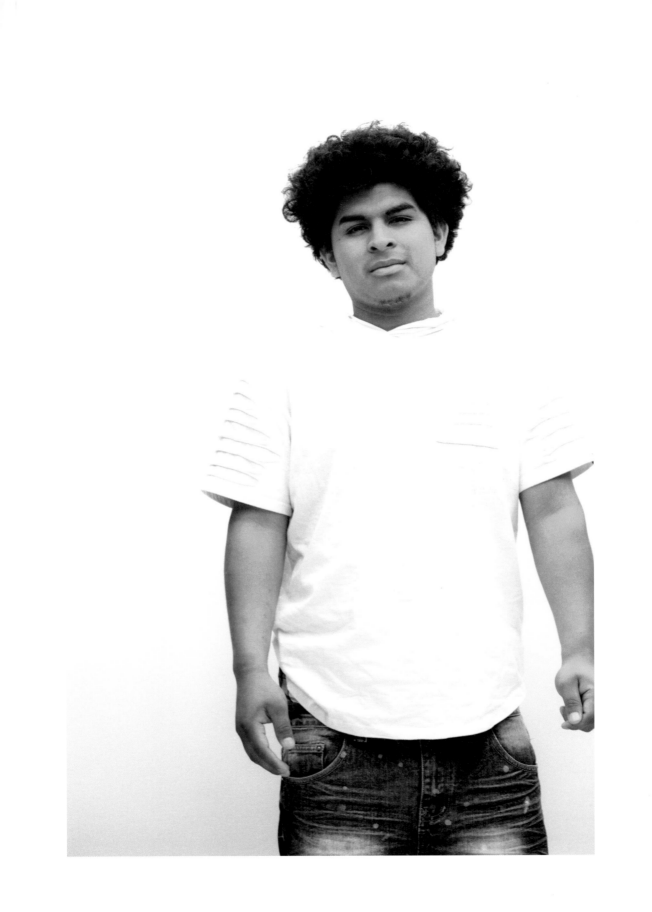

Azzaya Batbileg

age 17 / Ulaanbaatar, Mongolia (left)

I grew up with my grandparents in a little town in Mongolia. I moved to Ulaanbaatar with my parents when I was ten or eleven. Ulaanbaatar is very beautiful. It is surrounded by mountains. There are some tall buildings, but mostly they are three or four floors. The countryside in Mongolia is very beautiful. I am a performer, a contortionist, so I would go out to the countryside to perform with my friends. That was my favorite activity.

I came to the United States one year ago. Where I live now is so different from my country. There are so many skyscrapers, and so many different kinds of people. The weather is different. In Mongolia the summer is very hot, and the winter is very cold. In San Francisco, the weather is all kind of the same. I like San Francisco and Oakland, and I like Mongolia, too. I came here with my parents and my little sister, who is eight. I live in Downtown Oakland. I go to a Mongolian contortion center in San Francisco, and sometimes I perform.

When I think about home, I think about my house in Mongolia. There was one holiday where we all met up at my grandparents' house and we ate the food from my country. That's what I think of when I think of home.

with **Oyumaa Tuguldar** (right)
age 17 / Ulaan Baatar, Mongolia

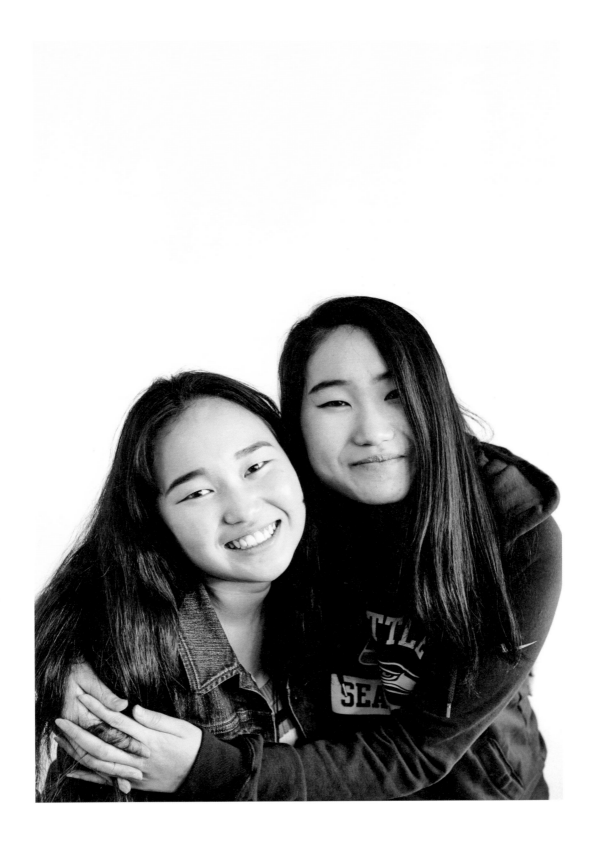

Suado Hussein

age 17 / Dadaab Refugee Complex, Kenya

My family is originally from Somalia. I was born and grew up in the Dadaab camp in Kenya, the largest refugee camp in the world. I lived in the camp with my mom and dad, my three brothers, and my two sisters. There was only a little window. I liked to eat rice and sambusa then. Sambusa is hard to make, but we just made it when we were fasting, or for special days. My dad died when I was four. My mom had to work to raise seven kids.

I came to the United States when I was twelve. I'm the second youngest in the family. I was scared when I first came because I didn't know English and didn't know anyone. I slept for two days after we first arrived. I remember it rained and we didn't have any umbrellas. I live with my whole family. I now live in the city, but used to live in the country. We live in a new building.

Home is a safe place. It is somewhere I have grown up. When you say the word "home," I think of my home in Kenya.

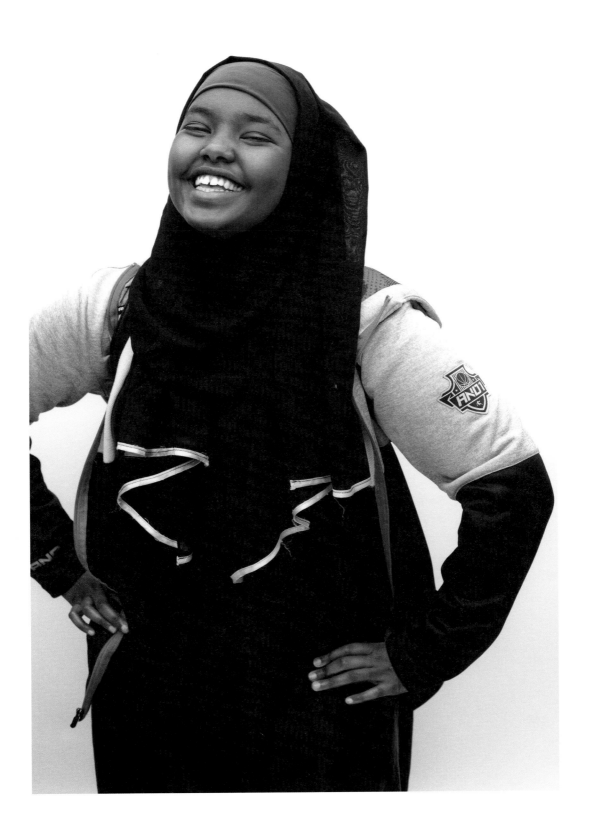

Calinda Maldonado

age 18 / San Francisco, California and Guatemala

I was born in San Francisco, and then moved to Guatemala when I was a little baby. I used to have my own room. I could smell my parents' room with my father's cologne. When I came home from school, I would greet my mom with a kiss and give my father a hug. I ate downstairs with my younger brother and sister. We ate rice and meat with fresh melon juice. There was a door in the living room that went to the patio where there were three small dogs and many big plants.

The apartment was in an alleyway, and in the door to the alley there was a table where the neighbors had a business of photographs. They took photos, printed them, and laminated them. I took the school bus one hour each way to private school. Sometimes I went to the park with my brother. We took the dogs and went to eat shave ice or chocolate strawberries. I could hear the engines of the tuk tuks and the birds.

Now I live in a little one-room apartment with seven people. I sleep in the living room on the top of a bunk bed, and my cousins and grandma sleep on the bottom. I hear all the cars that pass in the night; I hear my cousins fighting, my little cousin crying, and my auntie yelling. I don't feel loved where I live now.

When I think of home I think of peace and love; a place where I can be myself; a place where I can be loved and give love.

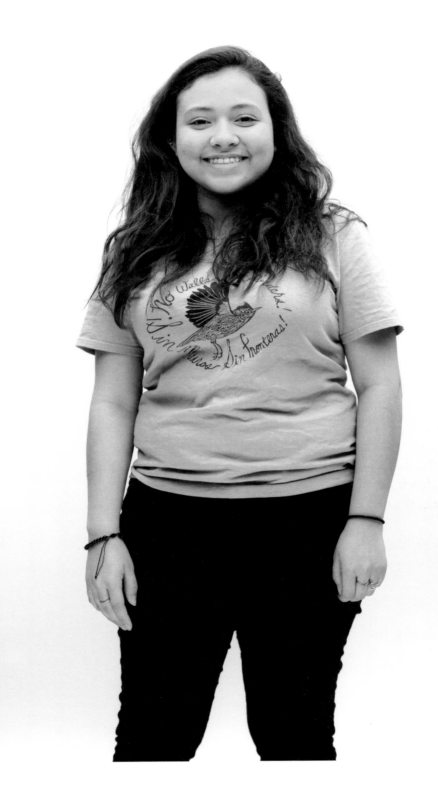

Wendy Avalos

age 16 / La Libertad, El Salvador (left)

Sergio Jimenez Diego

age 18 / Huehuetenango, Guatemala (right)

In El Salvador, I lived in a compound of three houses near the city. I lived with my whole family, each of us in some of the houses. There were eight of us in each house. Our dog was named Gecko. When I left, Gecko died; I think he was sad that I was leaving. I miss him.

Two years ago, we moved here to the United States. We live in a house with my two aunts and my uncle. My brother, Amarillo, lives here too. I don't like it here as much as El Salvador. It is not as beautiful.

I grew up in a small town in Guatemala. I lived with my aunt and my sister. I have another brother who came to the United States before me. My sister is fifteen and still in Guatemala with my mother. I'm not able to see them at all now.

I live in Oakland now. I've been here for one year and nine months. I live with my brother and his wife. My brother is twenty-nine. It's a so-so neighborhood. There are too many gangsters around. When you wear the color red, people think you are with that color. I like Lake Merritt and San Antonio Park, the outside spaces.

Home is wherever you live, but for me it is Guatemala and also the States because I have friends here. My home is where my friends are because we share everything.

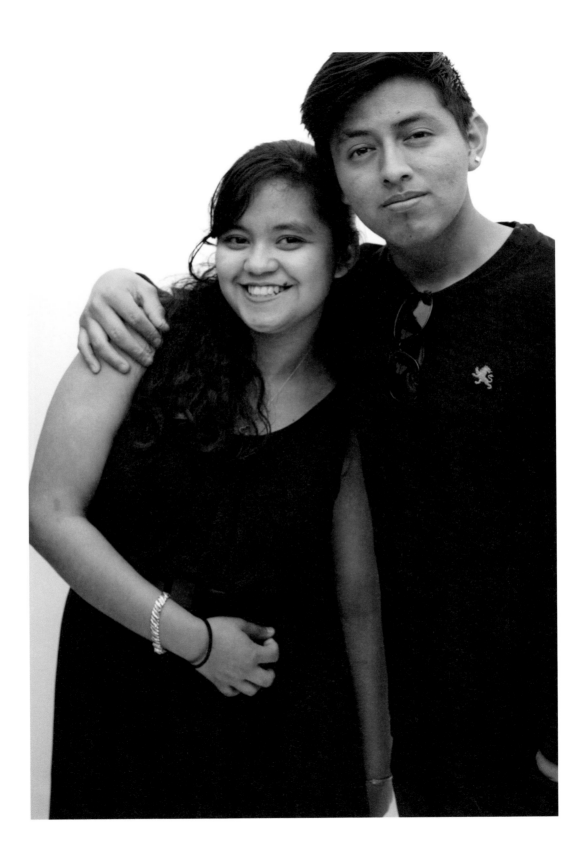

Fatima Dieng

age 14 / Columbus, Ohio and Dakar, Senegal

I was born in the United States, and then moved to Senegal when I was a baby. I grew up in Senegal. I don't know why we left the United States; it was my parent's decision to return to Senegal.

I left Senegal with my big sister in 2017 to come here for work and school. My sister and little brother are here and we live with my dad and aunt in an apartment. After school, I go to cooking classes and then do my homework.

It's safe here. Dakar was a big city and not always safe.

I miss my mom and family there. Home is where they are.

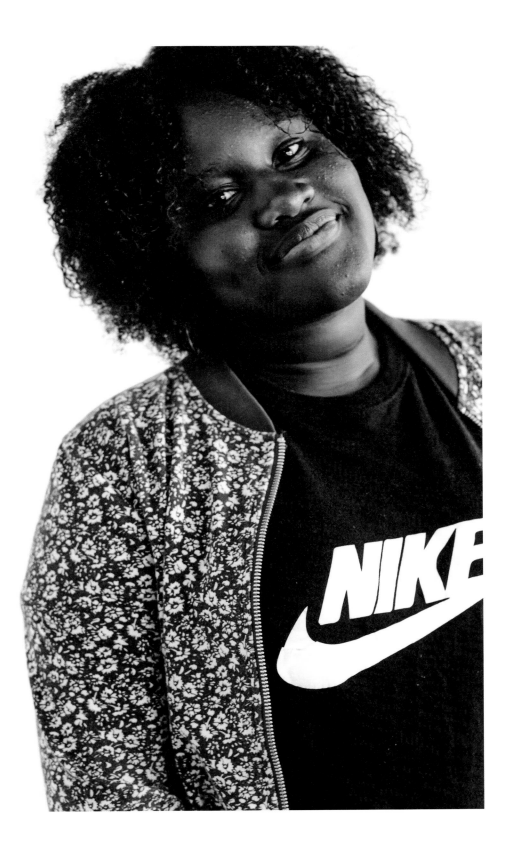

Rafael Ernesto Barrios Molina

age 18 / San Salvador, El Salvador

In my home in El Salvador, I had my own room. I remember my mom left some clothes in the closet and sometimes I would sleep with her sweater. My mom left when I was six. I woke up really early; she was all dressed and she kissed me and hugged me and said we would see each other again. One week later she came back because immigration took her. I heard someone trying to open the door, the dogs started to bark, and I saw someone walking up the stairs. I ran to her and hugged her. I stayed with her all night, while she was washing clothes. I was so happy, but the next day she was ready to go again. I knew she was leaving again. My mom taught me to cut my hair. I had to do everything for myself that my mom did for me.

I lived with my grandma and my older sister. I remember in the seventh grade my grandma started a bakery and I would smell the bread every day.

Now I live in an apartment. There is one room with four people. In the beginning, I slept on the sofa. The place is really noisy and many cars pass by. Sometimes, in the morning, I smell the neighbors smoking. I live with my mom and dad and my sister.

At the beginning I thought it was stupid that my parents left. I blamed them for everything. But now I see it was a smart choice. Maybe we don't have the life we dreamed of, but we live a little better, and we have what we need. They worked really hard to keep the family together. I think they would do the same thing if they had to do it over.

My little sister was born here. When she was four years old, my mom sent her to El Salvador, and she loved it, she felt like it was her place. My mom believed my younger sister needed to understand our culture. My sister, now she's ten, would still like to go back to El Salvador to visit.

My grandma is my everything. She took the place of my mom and my dad. I miss her. Mom and dad did a very good job being my parents even from afar. They always talk to me and tell me not to do bad things.

In the beginning, my grandma seemed rude to me because when I asked for help she said I could do it alone, but now I see that she really helped me to be the person I am today. I think without her I would be a different person, not as good of a person.

When you say "home," I think of the smell of fresh bread.

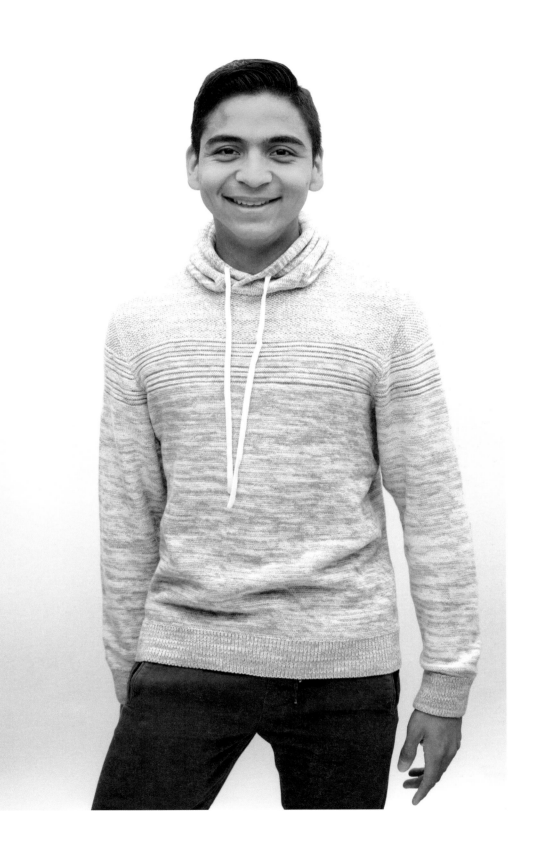

Urbano Perez Sales

age 18 / Huehuetenango, Guatemala

Where I came from was really beautiful. A place where you can walk outside at night and be happy. I grew up with my grandmother and my uncles because my mother was in the United States. I loved the rivers. There were beautiful rivers, a lot of trees, and mountains. Sometimes I got stressed, and I went to the creek to get calm and relaxed, and to just be alone and think about my life and everything. I also lived with my brother. I came to the United States in December 2013. It was my first time in an airplane.

When I came here the first thing I saw was the ocean, the beach in San Francisco. I saw the reflection of the light in the water; it was really cool. My home is a little small. I live with six members of my family: my brothers and my mother and my father. We all enjoy each other. We have family meetings every Friday at 7 p.m. and decide what to do for the weekend. I love the zoo in Oakland, I love the animals, and the mountains there remind me of Guatemala.

For me home is a house where you live, and where you have a place to sleep, a place where you can go and rest. For me home is my family. If I don't have family, I don't have home. Sometimes I feel sad because I left my grandmother in Guatemala, because she is also my family. I feel like I left some of my home in Guatemala, but I have some of it here. But I feel like they are happy because they know we are here.

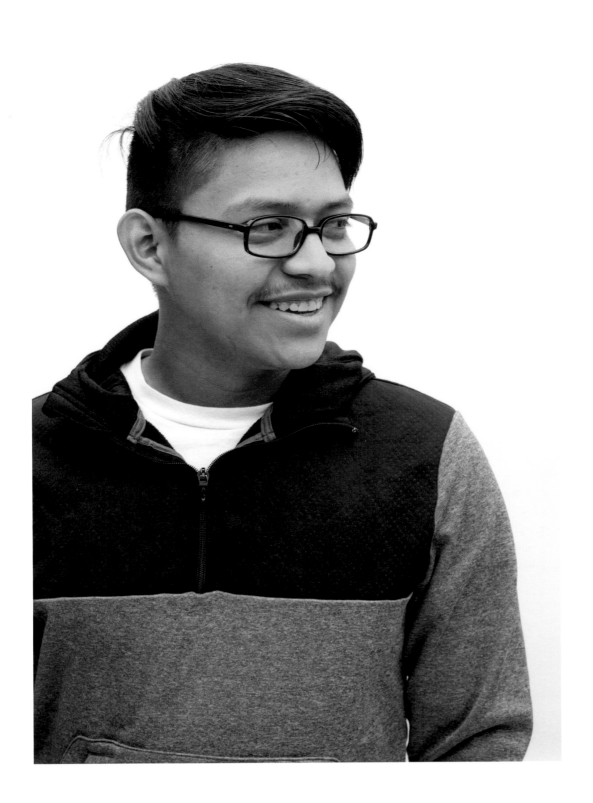

Jabeht Sandoval

age 16 / Guerrero, Mexico (left)

Daniella Villaran Cruz

age 16 / San Salvador, El Salvador (right)

Guerrero was beautiful. Almost every day, I used to be able to go to the beach near where we lived. But as I got older, I saw that it was becoming more and more dangerous. People were murdered, often for no reason, all around me. That's the reason I came here.

It's sometimes difficult for me here because I don't know a lot of English but it is good because I'm still with my family, except my grandparents, who are still in Mexico.

School is sometimes very hard for me because my English is not very good. When I get home, I am sometimes sad and sometimes happy. My mother is sick, so when I get home I help take care of her and I do my homework and clean the house. It is home because my family is there and I am where they are.

I grew up with my mom and dad in San Salvador. When I would wake up in the morning, they were awake. I have a younger brother as well. My aunt lived with us.

I live in a small apartment now with my mom, dad, brother, aunt, and my two-year-old cousin. When I leave school, I usually go to my house or sometimes I hang out with my friends. My brother and cousin are there. I play with them or I play with my phone and do my homework. My father and my aunt come home from work and we eat. My mom works until 10 p.m.

When I think of home, I think of my mom, my father, my brother, my aunt, my cousin, and my country. My family is home.

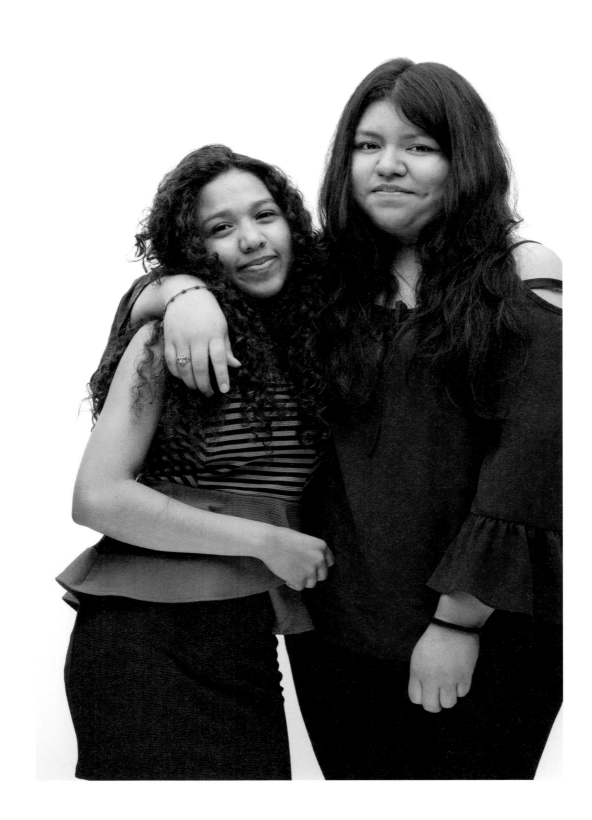

Luis Catalan Valencia

age 17 / Guerrero, Mexico (center)

We had a big family in Guerrero. I lived with my mom, my dad, my brother, and my uncles. The beach was close to my house. Every weekend I would go to the beach. My school was close as well. I was in dance class and we participated in events in the town, like Mother's Day. When I had free time in Guerrero, we would go to the park and visit the city. The food was delicious. Fish and tacos are not the same here.

Now I live in Oakland. It's so different—I feel my country was more beautiful. The beach here is very cold, which is not good for swimming. My friends are different as well. But here I feel safe. The things going on in my country were very violent. I moved here two years ago, in December 2015. We came to the border and we asked for permission to stay here, and they said yes, and so we could stay here. Oakland to me is so-so.

For me, home is a mixture of Mexico and here. I liked my house and my life in Mexico, but I have my family here. I feel safe here and in Mexico I didn't feel safe. In your home you should feel safe. I miss my dogs from Mexico, my friends and my family.

Victor Vasquez

age 19 / Mexico (right)

When I think of my home, I can see my dad. He is working, making bricks of mud. Our house was made of mud bricks. My mom is with him, cleaning the house. I am on the patio, playing with toy horses and a little toy truck.

There were a lot of plants where we lived. My mom had a rose garden, and there were tall pine trees all around. There were papaya trees, apple trees, and pear trees. We were in the countryside. My dad had chickens, cows, and sheep. We milked the cows. When we moved to Guadalajara, where I went to school, we lived in a small room with a kitchen and bathroom with my mom, sister, and I.

Now I live in a garage behind a house with my sister, who is pregnant. There are no windows in the garage. My grandma's sister lives in the house.

When I hear the word "home" I think, "Where my mom is."

with **Sam Sandoval** (left)
age 19 / Mexico

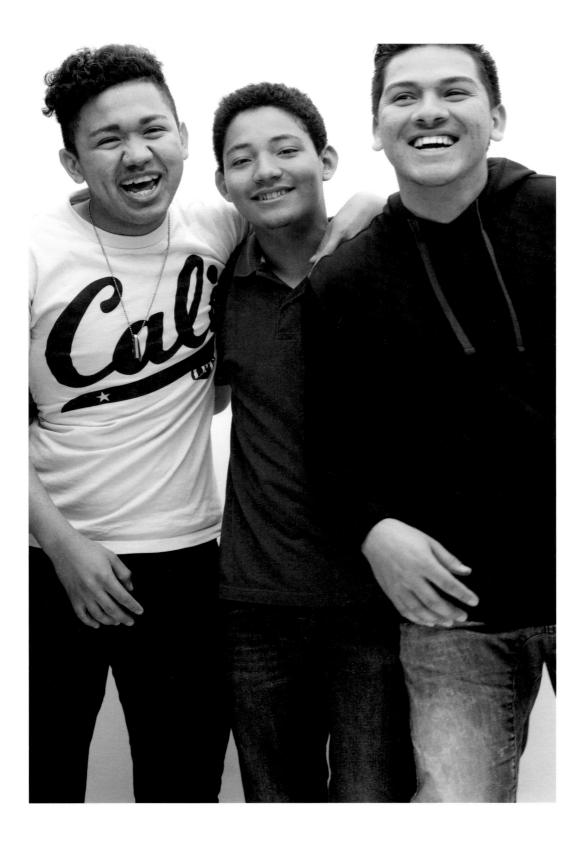

Vianney Alexander Longuele

age 16 / Brazzaville, Democratic Republic of the Congo

I was born in the Congo, but I lived in Gabon from age four to eight. We lived in a big house with my whole family. It was my cousins' and my grandparents' house. My cousin and I shared a room. Out my window, I could see the field where everyday after school we played soccer.

When I was eight, we moved to the United States. Now I live in a small apartment, with my parents and my little brother. It's much quieter. My brother and I share a room. Around us, there is just more concrete and the other apartment buildings. But I have friends in our building.

After school I still play soccer and basketball and chill with friends until dark.

All of the places I've lived are my home but if someone asks, I still say the Congo, because that's where I come from.

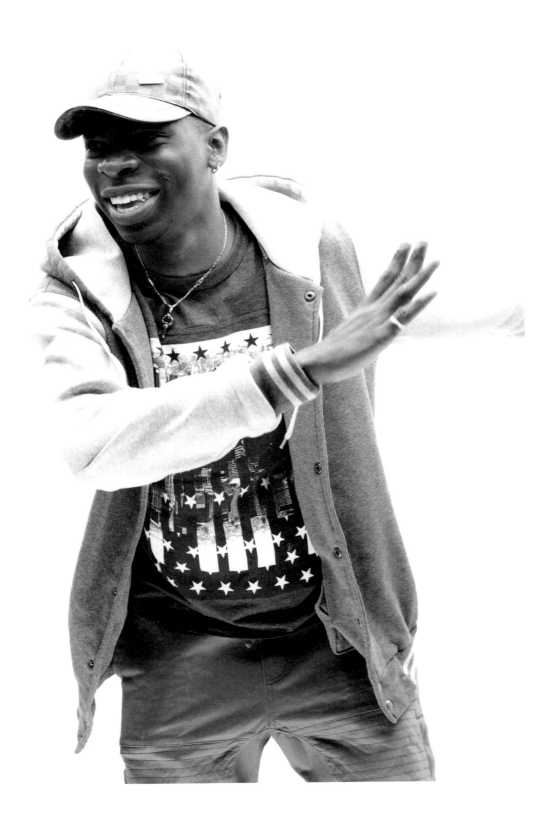

Gerardo Mercado

age 18 / La Libertad, El Salvador

I was happy in El Salvador because I was around my brothers. We didn't live with our parents; it was just us. Because I grew up with them, without them there is something missing—I feel that right now. When I was there we played soccer every day. Even though we were different ages, we had good communication; we never fought.

People say that my country is dangerous, which is true, but there are a lot of places that are good too. We have amazing rivers, parks, and mountains. There are not just bad things; there are good things too in my country. I miss my food, music, and traditions, because when you come here you stop doing those things and you have a new way of life.

I've lived in Oakland since 2013. I like that there are a lot of people here from my country, and from around the world. There is a lot of diversity. I used to think that all of the people here would just speak English, but when I came here I saw that people speak Spanish, too, and I could communicate with them, and I wasn't alone. It's kind of new but it's kind of the same because there is the language. I still play soccer, I play on the school team, and I play in tournaments. I take college classes. I feel stressed because I have a lot to do.

I think home means a place that you can come to and feel safe. You can go and do the stuff that you like with freedom. You feel connected to the people you are with. It doesn't matter where you are, or who those people are, as long as you feel safe with the people around you. That means you have a good home to come home to.

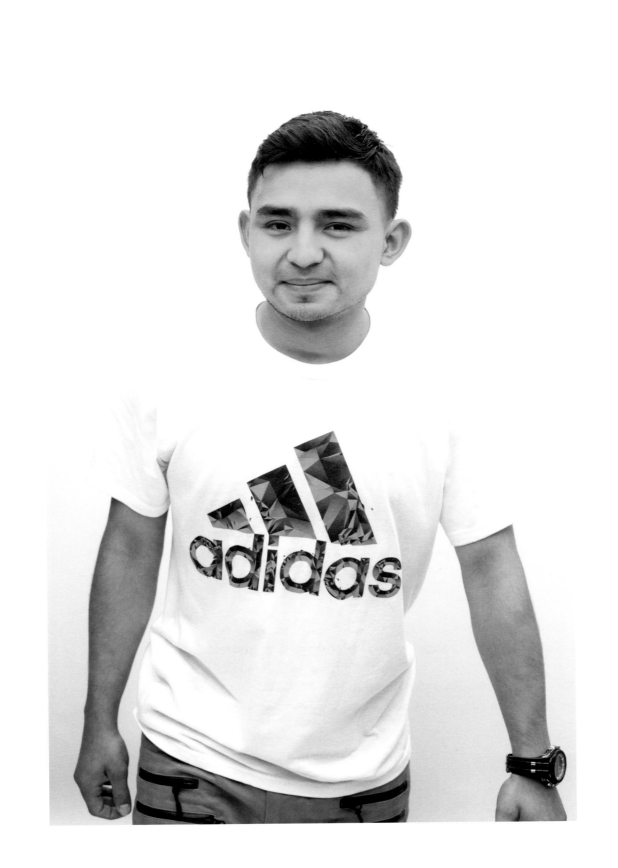

Akram Al-Orimi

age 18 / Sana'a, Yemen

I grew up in my whole country, all of it. For me, I don't want to live in a rich country. Yemen is perfect.

I live in East Oakland now. It's a dangerous street. Sometimes we hear shootings, cars doing donuts, and the police.

When I think about home, I think about Yemen. There is a war in Yemen now. The government is messed up.

People go to different cities because they don't want to die. They want to live. I want to go back to Yemen now.

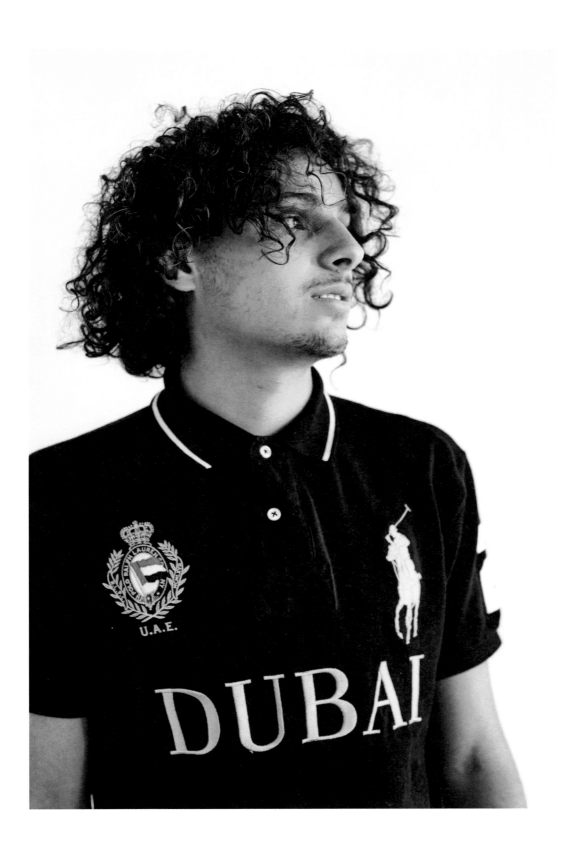

Alisson Hintz

age 17 / Usulután, El Salvador

I lived in many different places as a child. We moved around every few years to a different house. The last house I lived in in El Salvador, the house I liked the best, was with my grandmother.

My grandmother had a large store and we lived in the back, my grandparents, my parents, my siblings, and I all sharing the space. There was room for all of us and I liked it even though it was very loud during the day.

The house was near the center of town and a lot of people would come into the store. Sometimes it was loud, but I liked the noise.

When I was fourteen, we moved here to California. Now I live in a small house. It is a duplex and I live with just my parents and siblings.

I miss my grandparents and the noise. I am getting used to the idea that home can be a quiet place.

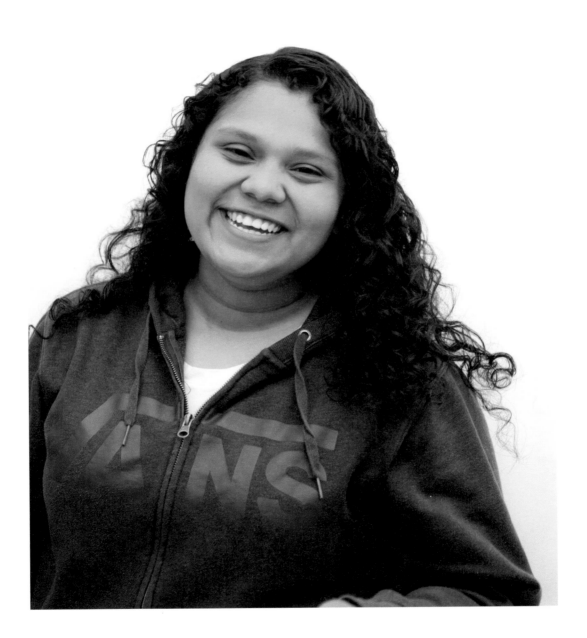

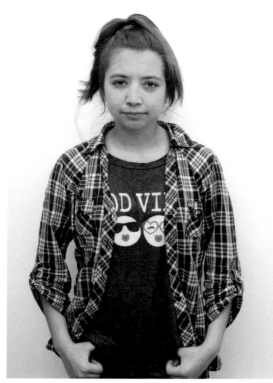

Shamila Hamidi
age 17 / Kabul, Afghanistan

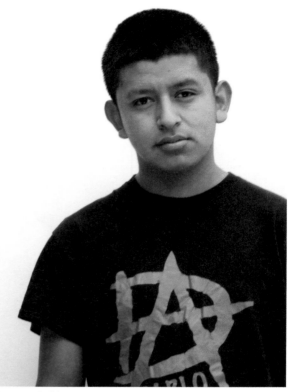

Lazaro Pablo
age 19 / Guatemala

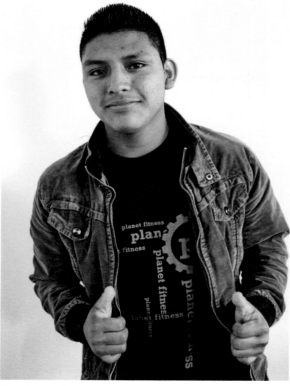

Ever Lopez Ramos
age 17 / Guatemala

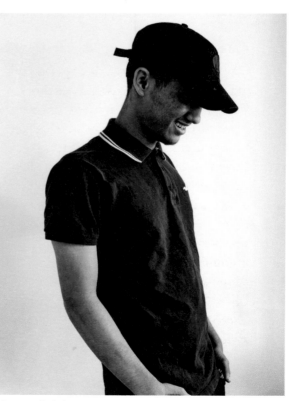

Muataz Saleh
age 17 / Yemen

Afterword

Oakland International High School is a delayed mirror of world events. War, conflict, and catastrophe happen around the world and, some months or years later, young people from these storied places begin showing up at Oakland International High School. They come here to begin again, to reconfigure their lives, their homes, and themselves. In our best iteration, we incarnate within our small community at OIHS what we wish we saw in our larger country.

Students at OIHS come from over thirty countries, but a country is a geopolitical invention, not a home. Roughly twenty percent of our students come from indigenous communities in the Guatemalan highlands, their families speaking little or no Spanish, in spite of it being Guatemala's official language. Our Karen students were born and raised in Thai refugee camps and are from an elusive country they know from YouTube videos, photographs and their parents' memories. What does home mean to these young people, and how do they define it?

Home is both a place and a concept, ever shifting and unfixed. The homes the students in these pages build for themselves are as pulsing and complex as the ones they left behind. They have uncertain futures, often unsure whether they will be able to stay in their current homes or even in this country. And yet they persist. They dream. They work hard toward a better future, not just for themselves but for all those around them. They are not just the leaders of tomorrow, but the leaders of right now. Because of them, this country can become a better home for us all.

Lauren Markham
Community School Program Manager
Oakland International High School
Author, *The Faraway Brothers: Two Young Migrants and the Making of an American Life*
May 2018

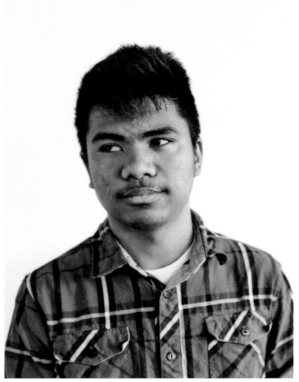

Benzuar Domingo
age 18 / Philippines

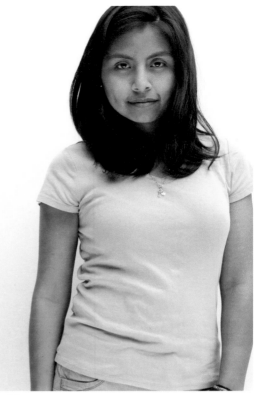

Yeybi Pablo
age 21 / Quiche Ixcan, Guatemala

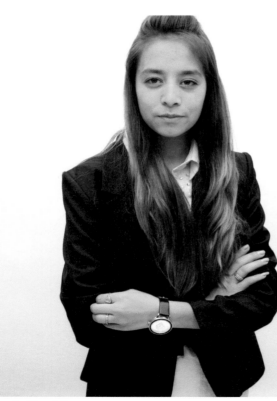

Sonila Hamidi
age 17 / Kabul, Afghanistan

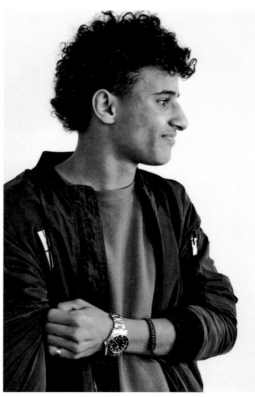

Yahya Banama
age 18 / Yemen

About Oakland International High School

Oakland International High School (OIHS) opened its doors in 2007 as a public school dedicated to serving Oakland's newcomer youth.

The school's mission is to enable newly arrived immigrant students to develop the academic, linguistic, and cultural skills necessary for success in high school, college, and beyond. As a Full Service Community School, OIHS provides wraparound services to support students' wellness and transitions to their new U.S. homes. At OIHS, English Language Development principles are integrated into all subject matters so that our students can actively participate in class and in the school community while learning collaboratively in small groups through hands-on interdisciplinary projects.

Oakland International High School's 390 students hail from over thirty countries. Many have fled war, persecution, extreme poverty, protracted political crises, and gang violence. They have made difficult journeys to the United States to rebuild their lives. Approximately 35 percent of OIHS students are undocumented, 30 percent are unaccompanied minors, 16 percent are refugees/asylees, and 15 percent are from active war zones. Over 95 percent live below the poverty level. In spite of all of these challenges, OIHS students dedicate themselves to making brighter futures for themselves and for their new adopted homeland.

Oakland International is a proud member of the Internationals Network for Public Schools, a nonprofit organization that supports dozens of international schools nationwide and whose mission is to provide quality education for recently arrived immigrants and to influence policy for English learners on a national scale.

Immigration Resources

California Immigrant Youth Justice Alliance

California Immigrant Youth Justice Alliance is a statewide immigrant youth-led alliance that focuses on placing immigrant youth in advocacy and policy delegations in order to ensure pro-immigrant policies go beyond legalization, and shed light on how the criminalization of immigrants varies based on identity.
ciyja.org

Internationals Network for Public Schools

Internationals Network's vision is to ensure that all recent immigrant students who are English language learners (ELLs) have access to a quality school education that prepares them for college, career, and full participation in democratic society. We provide quality public education for recently arrived immigrants by growing and sustaining a strong national network of innovative Internationals Schools, while sharing proven best practices and influencing policy for English language learners on a national scale.
internationalsnps.org

Kids in Need of Defense (KIND)

KIND represents unaccompanied immigrant and refugee children in their deportation proceedings.
supportkind.org

National Immigrant Justice Center

Heartland Alliance's National Immigrant Justice Center (NIJC) is dedicated to ensuring human rights protections and access to justice for all immigrants, refugees, and asylum seekers. With offices in Chicago, Indiana, and Washington, D.C., NIJC provides direct legal services to and advocates for these populations through policy reform, impact litigation, and public education. Since its founding three decades ago, NIJC has been unique in blending individual client advocacy with broad-based systemic change.
immigrantjustice.org

Restless Books Immigrant Writing Prize

The Restless Books Prize for New Immigrant Writing offers both publication and financial support to a first-generation immigrant writer who is writing their first book in English. Candidates must be first-generation residents of their country. "First-generation" can refer either to people born in another country who relocated, or to residents of a country whose parents were born elsewhere. The prize alternates between fiction and nonfiction annually.

restlessbooks.org/prize-for-new-immigrant-writing/

United We Dream

United We Dream is the largest immigrant youth-led network in the country. With over 400,000 members, their mission is to fight for justice and dignity for all immigrants. Their website includes a hotline as well as education and advocacy tools and resources.

unitedwedream.org

Young Center for Immigrant Children's Rights

The mission of the Young Center for Immigrant Children's Rights is to promote the best interests of unaccompanied immigrant children with due regard to the child's expressed wishes, according to the Convention on the Rights of the Child and state and federal law. The Young Center's goal is to change the immigration system so that children in immigration proceedings are recognized as children, and best interests are made a part of the decision making process.

theyoungcenter.org

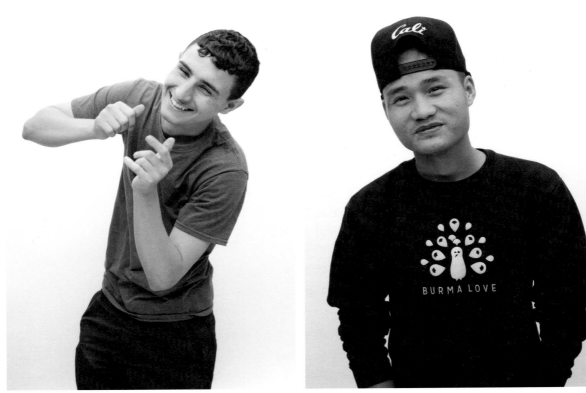

Mohammad Intezar
age 18 / Kabul, Afghanistan

Day Day Htoo
age 19 / Karen State, Myanmar

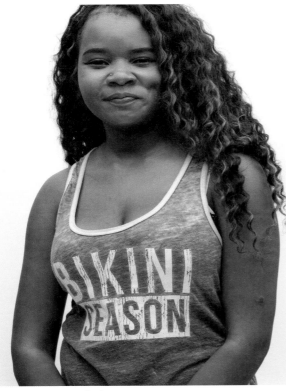

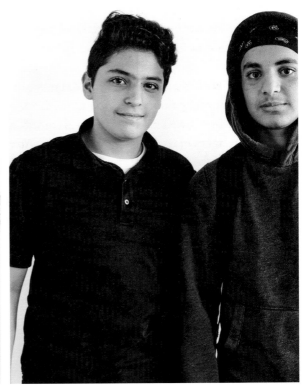

Mariam Nyirasafari
age 19 / Kigali, Rwanda

Bashar Allataifih
age 14 / Jordan

Khaled Mused
age 16 / Yemen